My Face for the World to See

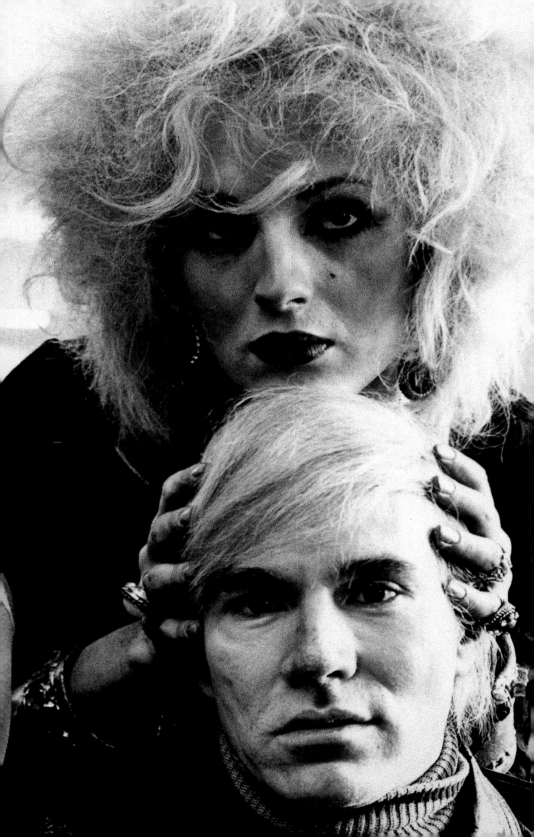

My Face for the World to See

the Diaries, Letters, and Drawings of Candy Darling

Andy Warhol Superstar

HARDY MARKS PUBLICATIONS • HONOLULU

Candy Says
Words and music by Lou Reed
©1969 (renewed 1997) OAKFIELD AVENUE MUSIC LTD.
All Rights Controlled and Administered by SCREEN GEMS-EMI MUSIC INC.
All Rights Reserved International Copyright Secured Used by Permission

Some material in this book originally appeared in
Candy Darling, Hanuman Books, 1992.

LAYOUT & DESIGN: Don Ed Hardy & Craig Okino.

EDITED BY: Jeremiah Newton, Francesca Passalacqua & D. E. Hardy.

Published by:
HARDY MARKS PUBLICATIONS
P.O. Box 90520
Honolulu, Hawaii 96835

ISBN 0-945367-21-X

CANDY SAYS

Candy says
 I've come to hate my body
 and all that it requires in this world
Candy says
 I'd like to know completely
 what others so discreetly talk about

I'm gonna watch the bluebirds fly
 over my shoulder
I'm gonna watch them pass me by
 maybe when I'm older
What do you think I'd see
 if I could walk away from me?

Candy says
 I hate quiet places
 that cause the smallest taste of what will be
Candy says
 I hate big decisions
 that causes endless revisions in my mind

I'm gonna watch the bluebirds fly
 over my shoulder
I'm gonna watch them pass me by
 maybe when I'm older
What do you think I'd see
 if I could walk away from me?

—Lou Reed, 1969

Foreward

*C*andy Darling was born ahead of her time, which was both her tragedy and the source of what is most unique, heroic and touching about her. To be a drag queen in the '90s is a career, but in the '60s it was a desperate calling, pursued only by those willing to risk a pariah existence. As Candy says in these diaries, "I am a star because I have always felt so alienated and I project this feeling to others."

When writing I *Shot Andy Warhol* my co-writer Daniel Minahan and I somewhat exaggerated the extent of Candy's friendship with Valerie Solanas, the revolutionary feminist who was Warhol's would-be assassin. She and Valerie were friends, but not as close as the film suggests. When writing the script we found ourselves adding more and more Candy, because we found the symbolic contrast between the two irresistible: the boy who dressed like a girl and girl who dressed like a boy. Both were social outlaws, rejected and dispossessed, but where Valerie was an outlaw because she rejected traditional femininity, Candy yearned for it. She wanted nothing more than to be a '50s housewife (or a debutante or a waitress or a showgirl), and became an outlaw because she refused to live as a prisoner of his/her biology.

With her humor and vulnerability, Candy could be described as the Marilyn Monroe of drag queens (anyone who has had the chance to see Candy in Warhol's *Women in Revolt* knows that she was a superb light comedienne) but her persona was a synthesis of all movie blondes. Andy Warhol once described drag queens as "ambulatory archives of movie star womanhood". Candy studied the movies like a doctoral candidate, and crystallised all her favorite elements of traditional femme culture into a dream life of what it is to be a woman.

These diaries, with their mixture of hearfelt prayers, soul searching, sharp social analysis, recipes and makeup hints, display all the classic "female" qualities: gentleness, sweetness, bitchiness, malice, passivity, vulnerability, masochism. (And a hilarious section on Women's Liberation, which she bitterly opposed.) There is also a sensitive intelligence at work, and a brutal honesty: "I don't mind that little smile around a person's face when they talk about me." As the greatest of all drag queen icons, Candy is beyond camp: you can always hear the heart beating beneath the artifice.

Mary Harron

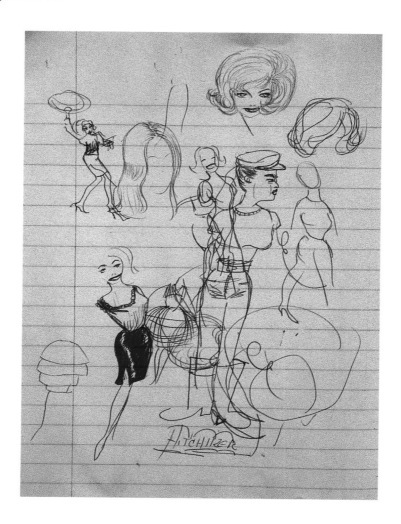

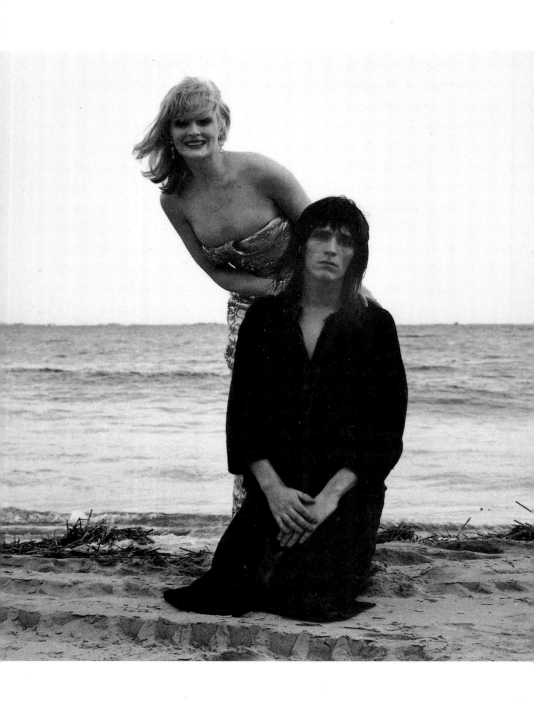

Introduction

This book is dedicated to Lorraine Newman Brooks, who taught Candy about the beauty of being an individual, Samuel Adams Green, who helped Candy to survive in NYC, and to Sean Duncan Cripps...I remember.

This is the voice of Candy Darling speaking, alive once again through her words, over twenty years since her death on March 21, 1974. As her friend, Candy often confided in me that her writings were an integral part of her creative process, so during the course of the day, she committed her thoughts to inexpensive soft-covered notebooks, the type used by school children, writing about such things as recipes (she was an awful, but nevertheless, hopeful cook), drafts of letters or ones she had completed but decided for one reason or another not to send, makeup tips, addresses and telephone numbers of the famous and unknown, lists of her favorite performers such as Joan Bennett, Kim Novak, Yvonne DeCarlo, and, of course, Lana Turner.

Then there are pages of speculation, words meant to be used as a rebuke or compliment, dialogue to be stored away for future use, perhaps for a play she was writing. She collected lists of one-liners and clever quips that she could trade with her friends Jackie Curtis or Holly Woodlawn. Candy's journal recorded her thoughts of the moment on that given day.

Candy liked to think of herself as an artist and would draw page after page of designs of dresses, eye make-up, and funny faces. She also liked doing cartoons and would send drawings to her cousin Kathy Michaud or her Uncle Donald, who in return sent illustrated letters

back. Drawings were done throughout her writings as a counterpoint to her mood at the time and to illustrate an important or salient fact.

She was born a he: James Lawrence Slattery, on November 24, 1944, to Theresa Phelan, who worked as a bookkeeper at Manhattan's glamorous Jockey Club, and Jim Slattery, an often violent alcoholic who squandered family finances at the racetrack. His very name inspired fear and hatred throughout Candy's short life.

There was a slightly older half-brother, Warren, by his mother's first marriage who would later, as an adult, deny Candy's existence to his own children; a grandfather once billed in vaudeville as "the strongest man in Boston," and Candy's Uncle Donald, who sent "campy" cards encouraging his nephew's sense of comic timing.

With this cast of characters in mind, it could be safely said that Jimmy's family, and even himself, could have been created through the pen of her champion and mentor, Tennessee Williams; but instead, in the best American tradition, Candy Darling created herself with the help of television's *Million Dollar Movie*.

During the 1950s, *Million Dollar Movie*, with its theme music borrowed from *Gone With the Wind* (the perfect dirge for a dying Hollywood) entertained little Jimmy, who often played hooky from the grim realities of school in order to watch the same movie aired three times a day, seven days a week. Hollywood and its mystique fascinated him and slowly transformed and transfigured the depressing reality of a lonely boy living a bleak existence in a small, Cape-Cod bungalow in Massapequa Park, Long Island. The frequency of a *Million Dollar Movie* film enabled Jimmy to carefully study the fiber of his favorite performers; makeup and costumes, the nuances and style of the actors, the contrived plots and dialogue. It wasn't long before he became a champion mimic—only Jimmy wasn't doing the male leads. His forte was the women, and he could and would perform for anyone who would listen.

But while most adults were amused by little Jimmy performing

Constance or Joan Bennett impersonations, his contemporaries were not; and soon Jimmy was further looked upon as a bizarre sort of local pariah. Yet this wasn't unusual for a child who had been judged as the Most Beautiful Baby Girl by Gertz Department Store. From the very beginning of his life, Jimmy Slattery was mistaken as a female. His skin, so milky white and smooth, his large, liquid brown eyes framed with thick eyelashes—there was just a way about Jimmy that could not be denied.

However, local parents did not want their children playing with him and, thus ostracized, this unusual child was left to his own means, content to live in a faux Technicolor Hollywood dream world writing letters to his cousin Kathy Michaud in which they discussed earth-shattering issues such as Kim Novak's fan club and Lana Turner's secret romance. *Photoplay* and *Modern Screen* were their favorites, along with the publication *Vice Squad*.

As time went by, with his now-divorced mother working at the local telephone company during the days and his brother ensconced in the service, Jimmy had ample time to begin experimenting with his mother's makeup and clothing. He loved to draw luxurious colored bubble baths while playing tango and mambo music on the stereo and acting out scenes from the *The Prodigal*.

As a teenager, Jimmy, who wrote daily in his diary, learned about the mysteries of sex from a salesman in a local children's shoe store. When Jimmy was 17, his mother, alerted by a local snoop, confronted Jimmy with the shattering news that he had been seen dressed "like a girl" entering a local gay bar called *The Hayloft*. Taking his mother gently by the hand, Jimmy asked her not to say a word, but to sit at the kitchen table and wait. Minutes passed. Terry later recalled that morning so many years ago when she waited, upset and full of questions, listening to the kitchen clock ticking so loudly. Finally, the door opened and her son came out transformed, as it were, into a beautiful young woman. Candy Darling was born. "I knew then," her mother would later tell me,

"that I couldn't stop Jimmy. Candy was just too beautiful and talented."

A new name was needed and her first *nom de plume* would be Hope Slattery, but it was quickly cast aside for Candy because of her love of sweets. She told strangers that the name Darling came from her father, the "senator, "who lived on a plantation down South surrounded by loving "darkies" who crooned to her at night. She told Andy Warhol that "...the Darling fortune is made from a chain of dry cleaning stores and we're just cleaning up!" But the truth of her humble beginnings were kept a secret to everyone save her closest friends. Because Candy lived nearly an hour away from Manhattan in her "country house," she made use of the Long Island Railroad, leaving Massapequa Park late at night so nosy neighbors couldn't spy and make her mother's life more miserable then it already was. Because of harsh laws at the time, Candy still dressed like a male, wearing simple, dark clothing (a habit she kept for the rest of her life), but she eventually dyed her brown hair platinum blond. While the stations zipped by, she transformed herself using makeup. Occasionally she would notice another blond Long Island resident on the train, an up-and-coming actress by the name of Joey Heatherton; but they never spoke, preferring the anonymity of these encounters, both lost in their own worlds.

As time passed, Candy made friends through the "salon" of Seymour Levy on Bleecker Street in New York's Greenwich Village. At night, she danced at a nearby after-hours club, *The Tenth of Always*, where she first espied Andy Warhol with Lou Reed. For Candy, her direct route to "stardom" would be mapped out for her by Jackie Curtis, "the world's youngest playwright," who wrote the part of Nola Noonan for Candy. The comedy *Glamour, Glory and Gold* was written in one hour while 15-year-old Curtis rode the L.I.R.R.

More assistance would be through friend poet/actor/Superstar Taylor Meade, who brought the man who Candy considered her mentor until the end, Andy Warhol, to see her performance in Jackie's play. Other friends of the mid-'60s include playwright Bob Heide, whose

plays were performed at the now-legendary Café Cino, where unknown Harvey Keitel chewed the scenery. Clyde Meltzer, aka Taffy Terrific, aka Taffy Titz, was a performer who introduced her to the Brooklyn crowd. Soon things began moving fast, and she was swept up in the glamor of the Andy Warhol/Paul Morrissey Factory where, on any given day, one could find personalities such as Truman Capote, Judy Garland, Jim Morrison, and a host of handsome and beautiful unknowns recruited from the ranks of delivery boys, socialites, waitresses, and college students.

She managed to create an interesting life and she was loved by all, though Candy always had great concerns wondering where the next dollar was coming from and how to repair her teeth, which were in poor shape after years of eating sweets. Although Warhol doled out small sums of money to his performers, financially life was difficult and often depressing. But she had the safety and security of the back room of *Max's Kansas City* and a wonderous assortment of loyal friends such as Sam Green, Lorraine Newman, Lauren Hutton, Julie Newmar, Sylvia Miles, Tinkerbelle, Francesca Passalacqua, Lennie Barrin, Pandora, Julie Baumgold, George Abagnalo, Cyrinda Foxe, Tom Eyen, Geraldine Smith, Francesco Scavullo, Tony Mansfield, Tula Inez Hanley, and yours truly. Lou Reed composed *Candy Says* for her (dedicated to her) along with a memorable section of *Walk on the Wild Side*. Still, true happiness remained distant; but she held onto her dreams of stardom, new teeth, a permanent place to live, and perhaps one day, a man to love her.

The earliest writings are excerpts from Jimmy Slattery's diary beginning in 1958 (when he was 14 years old). Several years later, reborn as Candy Darling, his world had radically changed. From the mid-'60s to the early '70s, Candy kept active doing Off-Off Broadway and two films for Warhol/Morrissey: *Flesh* (1968) and *Women In Revolt* (1971), several independent films: *Brand X* and *Silent Night/Bloody Night*; a co-starring role as a gay-bashing victim in *Some of my Best*

Friends Are..., a memorable scene in *Klute* with Jane Fonda, and *Lady Liberty* with Sophia Loren. A quote Candy used many times was "I've had small parts in big pictures and big parts in small pictures." In 1971 she went to Vienna, where she did two films for director Werner Schroeter, the first entitled *The Death of Maria Malibran*. Unfortunately, the second film was never released.

Several years ago, director Mary Harron approached me in the pre-planning stages of what was to be *I Shot Andy Warhol*. She had heard of my friendship with would-be-Warhol-assassin Valerie Solanas and later read my writing on this relationship and incorporated it into her film, along with some of Candy's words. Through our conversations it didn't take much persuasion to convince Mary of the importance of using Candy Darling as a character in her film. Although it is impossible to duplicate an individual, I personally felt that Stephen Dorff gave a haunting performance capturing Candy's very essence. For me, Candy Darling lived again on screen. And I may add that actor Danny Morganstern portrayed a very credible Jeremiah! Mary created an era through her work and has emerged as an important new director.

Over two decades have passed since the death of my friend; and in those years, the world has indeed changed. Candy would have been severely distraught by the deaths of Andy Warhol, Tinkerbelle, Jackie Curtis, Tom Eyen, Charles Ludlum, Sharron Lyn Reed, Eugene Siefke, and so many others who made up the rich and varied weave of her world.

She would have been proud of the Harvey Milk School, an institution in Manhattan that educates and takes care of gay, lesbian and transgendered youth, something inconceivable in her lifetime. The onslaught of AIDS would have devastated her life as it has devastated ours.

Ms. Darling would never have imagined how many people would miss her. At the scene of her funeral, with hundreds of mourners

present, a stretch limousine pulled up to Frank E. Campbell's just as her flower bedecked casket was being carried out, and a tinted window rolled down. Its passenger, Gloria Swanson, saluted the coffin with a gloved hand.

Throughout the years I have attempted to keep my unforgettable friend alive. In life, many of her dreams eluded her, but she lives again through her words, drawings, and photographs.

Note: Amongst Candy's writings are references to the following people: Sandy Amerling (her first manager); Kathy Michaud (her cousin, with whom she had many interests in common); Off-off Broadway's legendary Jackie Curtis; Holly Woodlawn (co-star of Flesh and Women In Revolt with Jackie Curtis); Ron Link (the man who "discovered" Candy); playwright Bob Heide; Tony Mansfield (Jayne Mansfield's "baby brother" and first disc jockey at many important New York clubs); Warren and Maryann (Candy's half-brother and sister-in-law); Bill King (the late photographer), Pat Thorne (a Greenwich Village friend and companion of Valerie Solanas); Ron Delsener (producer); George Abagnalo (co-screenwriter of Warhol's Bad); and friend Jim Hanafy.

Jeremiah Newton

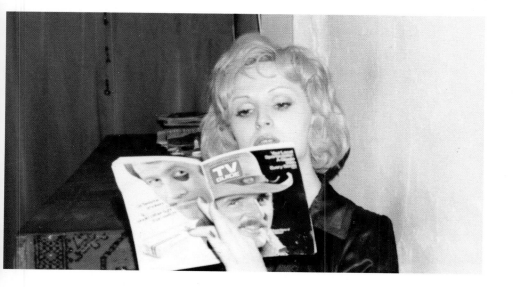

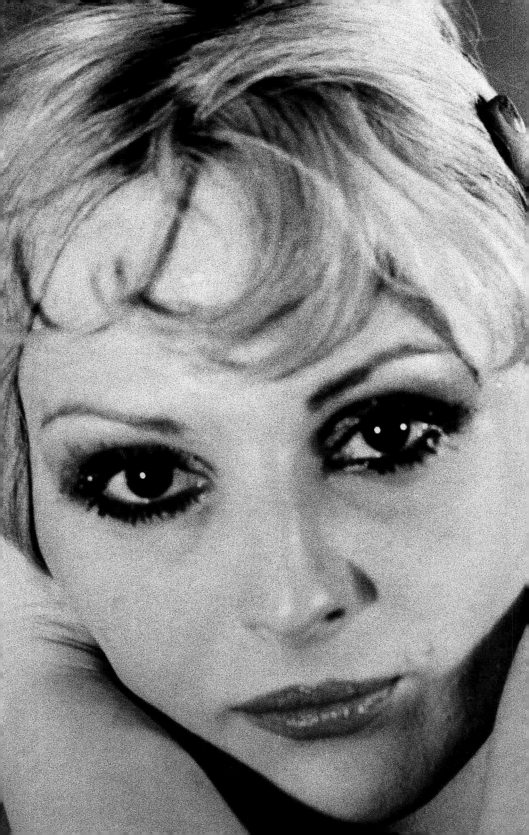

Candy Remembered

*L*ike Candy, I, too, came from out on the Island. Like many other children of the '40s and '50s whose parents were from the city, we were taken from the place of our birth to a presumably safer and more child-friendly atmosphere. And like many of the teenagers of the '50s and '60s, we felt confined and restricted by such a place and could not wait to return to the city that our parents had struggled so hard to leave.

In the early '70s I would travel around the country until my money ran out and then return to New York to earn more so that I could leave again. I met Candy during one of those work periods. I had met Jeremiah first; he was a friend of a one-time hitchhiking companion. Jeremiah and I were both living in less-than favorable conditions in different sections of Brooklyn, so we decided to pool our resources and get an apartment together in Manhattan. We found a one bedroom apartment that we could afford on the Upper West Side. We flipped a coin for the bedroom, and Jeremiah got it. I got the convertible couch in the living room. This arrangement worked out fine while it was only the two of us. But before long Jeremiah started telling me about his friend Candy who was in Europe making films. She'd return to America soon, he said, and would need a place to stay. Would I object to her coming to live with us? He said she'd live in his room with him, so I agreed.

Candy arrived. She was stunningly beautiful with an ethereal quality. She had suitcases full of gowns and cosmetics. My only interest in how I looked was what I had to wear in order keep a good-paying job. I called it putting on the disguise, feeling that anything

other than natural was a lie. When I was off work, I'd wear what my other friends wore—jeans and t-shirts, and no makeup. But when I went out with Candy, even just to the market, she'd insist that I dress up, often in one of her gowns. She'd do my makeup and hair; and I indulged her. It was yet another disguise to add to the mix. But no matter what type gown she dressed me in or how she did my makeup or hair, I still felt dowdy and butch next to her. She was the tall and glamorous one; I felt short and dumpy.

This arrangement worked well for a short while, but before long, two more people were living in our small apartment. It became clear that we'd have to move, and there was no way we could afford to stay in Manhattan. We found a house in Brooklyn, in Flatbush, near Park Slope, on a block that was partly renovated. We were renting two floors of the house, the rest was still undergoing construction. There were five of us now—Jeremiah and his lover, Joseph Ratinski, Candy, me, and a new friend, Kathy. The unrenovated portion of the block consisted mainly of Puerto Rican immigrants who could not understand what type of a household this was—a gay couple, two young, single (or were they also a couple?) women, and this tall, beautiful blond. There were people coming and going from our place at all hours, and the neighbors made their disgust plainly evident. Kathy and I were the only ones who held straight, 9–5 jobs. We also had different standards of housekeeping from our other roommates. It was nearly impossible to get Candy to clean up after herself. She would finally relent only after being asked a number of times to do the chores, but she would turn it into a suffering heroine role. Quoting lines from her favorite melodramas, she'd turn the task into a performance.

Many times when getting ready for work I would discover that the dress I'd intended to wear had been torn. When I'd ask Candy if she knew what had happened to it, she would deny knowing anything at first; but eventually she'd admit that she *had* to borrow it since her

appearance was surely more important than mine. I tried, in vain, to tell her that my clothes would not be able to stretch to accommodate her frame and to please leave them alone. I was working for a company that had connections with the garment industry. Through these connections I had the opportunity to purchase 12 dozen pairs of stockings, which I naturally expected would last throughout this work period. I wrongly assumed that these would be safe from Candy since there was a greater disparity between our shoe sizes than our dress sizes. While I was at work, however, during one of her foraging trips to my closet, Candy discovered my cache. Within a few short weeks, the supply of stockings was completely depleted. Of course, I knew whom to question; and Candy finally admitted that she had *had* to use them since she had to look good when she went out and that I should be happy that I was able to contribute to the cause.

Candy never had any money and always had to beg Andy to help her. She'd usually get promises of money, or occasionally a token bit; but it was never enough to live on. She lived off other people, especially her good friend and supporter, Sam Green.

Most of my off-time was spent with other friends, but periodically I'd get caught up in what Candy and Jeremiah were doing, usually if an opening or party was involved. I'd get dressed in a outfit that met Candy's approval, and we'd head for Manhattan. Men would be attracted to her, but I was fearful of what would happen if they found out that she was not exactly what she seemed. Often after a long night in Manhattan, Candy and I would share a cab home; and she would reveal to me her pain. She was not attracted to homosexual men since she was not psychologically a man. It was a heterosexual man that she wanted but felt that that would be impossible as she was.

Many weekends we would take the Long Island Railroad together to visit our families. She got off two stops before mine. I would read, but she was always writing. I never knew what the writings were until we began this project.

When I had saved enough money, I again left New York, but this time I never returned there to live. I never saw Candy again. My travels led me to San Diego where I met the man who would become my husband. The desktop publishing company that we eventually formed made this book possible.

Candy lived a full life of fantasy. She had an image of what she should be, what she was capable of being; but she was born in the wrong package. She had a skewed view of her importance, thinking that everyone knew who she was and how famous she was. The truth would have been too hard to face, that she looked the part, *almost* perfectly. She wanted the transformation to be complete but had no way of achieving it.

The final ironic tragedy is that Candy, who did not do drugs or have wild sexual adventures, died at such a young age, simply because she took hormones to make her more of what she knew she was.

Francesca Passalacqua

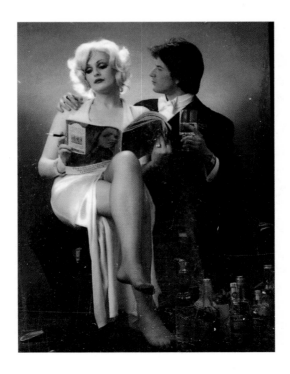

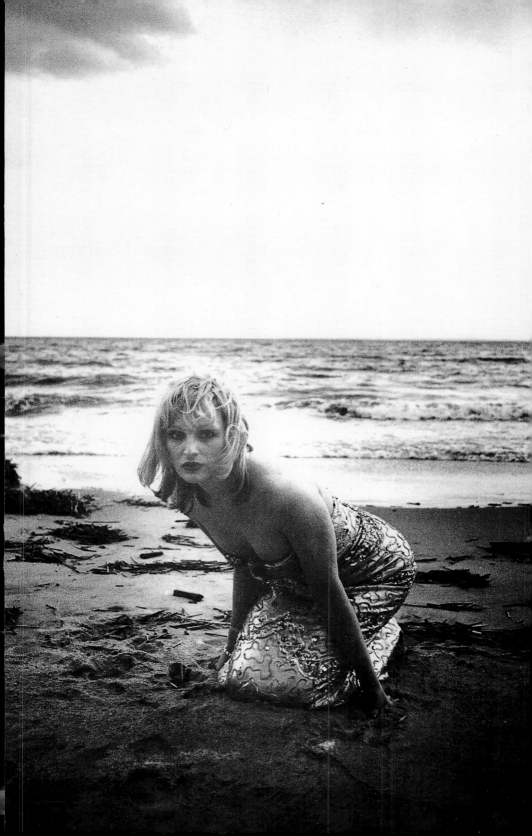

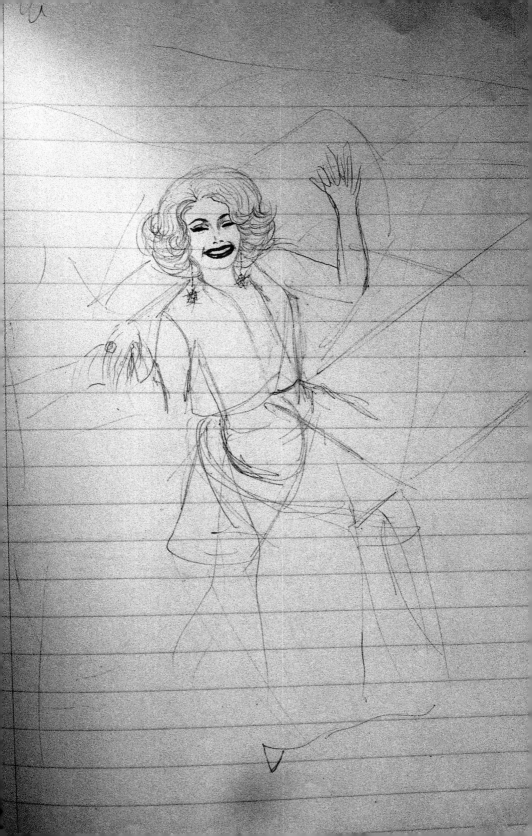

EDITOR'S NOTE

Material was excerpted from a number of diaries, all in the collection of Jeremiah Newton. Entries often spanned several years and are in no particular chronological order. The most dramatic is a spiral-bound notebook initially filled with young Jimmy's notes from junior high school classes that segues in later pages to the razor-sharp wit and poignant observations of the mature Candy.

Handwriting styles vary widely in these journals as Candy "tried on" various psychological roles. Many of the entries are drafts of letters to friends and admired stars, and bits of dialogue from movies she loved, which mingle freely with her own witticisms. True to her essence, it is impossible to determine where actual events ("real life") end and fantasy begins.

Spelling and punctuation have been corrected throughout.

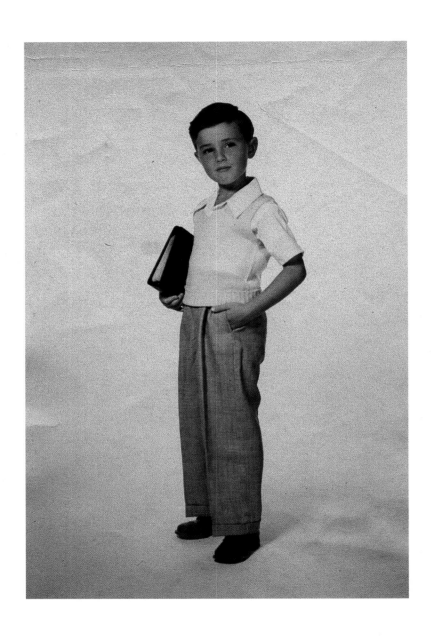

No talking without permission

Don't use tools without permission

No running in shop

No running up or down ramp

Make sure all tools are clean before being put away

No fooling in shop

No pushing or shoving

Magazine Rack

1)

END

End

2)

Bottom

Bottom

3)

Aluminum Sheeting

January 6 Monday

Today was the first day of school. Oh how I hate school!
I have to get up at 7:00 a.m. promptly instead of 11:00 or
10:00 during my beautiful vacation. I can't wait until the
next one. Sue & I are friends again. Went over Karen's
today; her mother is strict, and Momma wouldn't let me
eat, she says I'm getting too fat. I am!!! It's 11:00 p.m., I
better go to sleep now.

♥　　　♥　　　♥

January 7 Tuesday

Got up late this morning. Got to school (prison) very
late. I walked home with Ronald Esposito and it was
snowing at 2:30 p.m. and until 11:30 p.m. It's 11:30 now,
and it's still snowing. Made a soap carving today it came
out awful. It was supposed to be a fish. I didn't have
Gym today. I lost my gym suit. Goodie Gumdrops.
I HATE gym. Nobody likes it, you have to take showers &
do exercises & all. Phooey. The snow is so deep there
may not be school tomorrow. YIPPIE

Today is the Birthday of _Doodyville_

Today they announced
my name over the
loud speaker and told m
to come down to the
office!! I didn't go
because I didn't know
when to go this kid wa
yakkin during home-r
announce, ments, tina
I went down at 8
Period when school u
almost over and got
my head yelled off
have to study for th
Mid-Terms. Ma said
I'd get the Bongo Dru.
if I passed everyth
I hope I Pass.

9TH DAY

5 DAYS TO COME

Y OF WEEK

FEBRUARY **8**

Friday

lay is the Birthday of

Momma and I went
to A & S again today
she had to get a
different size in the
slacks. I also got
a NEW COAT!!!!!!
Its beautiful. It's
red and has those
wooden pegs and a hood
and fur lining.
We went to Morrow's
but Linda wasn't
there

← Back

you can take the
hood off. It's
really beautiful.

January 14 Tuesday

I almost couldn't get up this morning. I was supposed to attend a meeting at 2:30 for planning my Program (subjects) for next year in 9th grade. But instead I went over to Pat's. We went downtown into this abandoned store & broke windows & all. We got a lift to his house & my mother picked me up. It was terrible coming home in the rain & snow. I got it too. I can't go there any more.

♥ ♥ ♥

January 15 Wednesday

Today they announced my name over the loudspeaker and told me to come down to the office!! I didn't go because I didn't know when to go, this kid was yakkin' during homeroom announcements. Finally I went down at 8th Period when school was almost over and got my head yelled off. I have to study for the Mid-Terms.
Ma said I'd get the Bongo Drums if I passed everything.
I hope I pass.

H DAY
DAYS TO COME
OF WEEK

JANUARY **17**
Friday

is the Birthday of

the tests were as
boring as they
could be. I nearly
fainted keeping still
for hours & hours.
I didn't eat till
12:15 P.M. I didn't
get sick but I had
a stomach ache
until I got out of
school because first
my stomach was
empty then I glutted
it all up. Tommor-
rows = saturday =
(Praise to the Lord)
I hurt my left
underarm terribly
I can't stand it.

ain't I
cute

Today is the Birthday of

I was sick today just as I was Sunday. I felt nautious when I got up and had a fever, sore throat headache, and a pain in my temples. It went away though. Guess I got the crup. Got a letter from Aunt Jean and Bobbie today. I saw the "Late Show" and the "Late Late Show" tonight

ELIZA

February 28 Thurs.

Today Momma took me to the doctor & he took off the
bandages. The scar is so ugly I can hardly bear to look
at it. When I first saw it I said,
"Oh no, is that my flesh?"

Today is the Birthday of

TODAY ME, JOHN SEYMOUR,
AND JIMMY RILEY, WENT TO
MASSAPEQUA ON THE TRACKS.
WE WERE IN THESE OLD
HOUSES. WE WERE
CHASED WHEREVER WE
WENT. MY LITTLE KITTEN
ELIZA-JAYNE IS GONE.
I FEEL TERRIBLE
ABOUT IT. MY POOR
BABY. (I HOPE NOBODY
IS READING THIS.
"THIS MEANS YOU!
NOSEY! DO I
GO THROUGH YOUR
DIARY?) I BETTER
GET SOMETHING FOR
THIS DANDRUFF.

1 ST DAY
4 DAYS TO COME
y OF WEEK

MARCH
Saturday 22

day is the Birthday of

DEAR DIARY:
DONALD IS HERE TODAY. HE
CAME ABOOT 6 "O" clock.
HE'S GOT SOME SENCE
OF HUMOR! HE'S REALLY
FUNNY HE HAS US IN
STITCHES. TODAY momma
AND I GOT NEW SHOES.

momma's

BIEGE
COLLRED

THEY ARE
CALF SKIN

.... SHE ALSO GOT

BLACK
+
WHITE
s

a pair of saddle shoes

I GOT a pair of black snapjack

COOL!

May 28 Wednesday

Today I was in lunch line. Everyone was talking & so was I. So all of a sudden some teacher—Mr. Lagumina pulls me out & sends me to the end of the line. So I asked him why and he said quote "For no reason" unquote. So then I said "Then why do I have to go?" With that he puts his hand on my neck & pushes me forward. I put his hand down then he pushed me across the hall & pasted me in the face & said to get in the office!! I had a big red hand-print on my face! Then this girl who works in the office—Joan—asked me what happened. Then I went to Mr. Jury. He didn't do a thing. My mother's coming up tomorrow. They ain't gonna belt me.

Dear Pat,

Hi. Nobody loves me or wants me. I lead a dull uninteresting existence. At least you have your mother to turn to. I have Kathy but she isn't near my locale. I am in homeroom now. There's a bunch of chicks in here and they all hate me. Someday I'll be a movie star.....that's it!! And I'll be rich and famous and have all the friends I want. Can't you just picture some "dramatic chick" saying this:

> You're just a
> star-struck
> starry-eyed kid
> Stella

So how's tricks? I'm the "Earthy" type huh? Hell!!!!

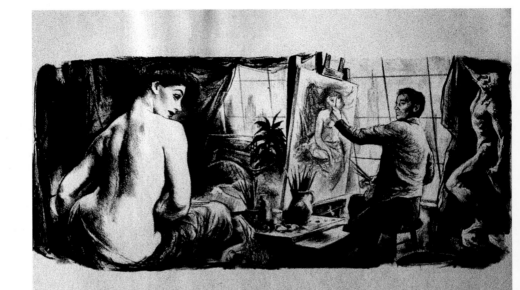

FAMOUS ARTISTS

Talent test

```
MR   J   SLATTERY        111
79 FIRST AVE              35
MASSAPEQUA PK N Y        030
```

Prepared by Members of the Faculty of the

FAMOUS ARTISTS SCHOOLS

Westport, Connecticut

 Accredited by the Accrediting Commission of the National Home Study Council, Washington, D.C., a nationally-recognized accrediting agency as defined by the United States Office of Education.

B-3 Your powers of observation

Complete the outline sketch alongside the original, using an ordinary soft pencil. Before you begin, study the lines in the original drawing, noting their length, thickness, weight and direction.

Grade _____

B-4 Your imagination as an illustrator

Complete the picture by adding whatever other figures and objects you think are necessary to tell an interesting pictorial story. Let your imagination have free rein. Do not add any more shading than is shown in the original drawing. This is not a test of your draftsmanship but of your imagination. Keep the drawing simple.

Grade _____

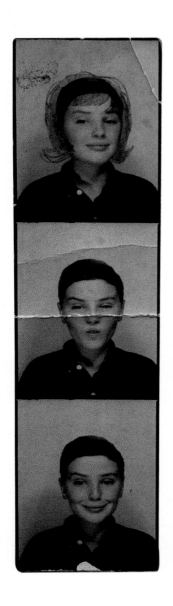

Tuesday, October 30 1962

It is 2:30 a.m. and I can't get to sleep. I can never get to
sleep at night. Not even with sleeping pills. This is a
pretty old diary. I was 13 when I had it. Now I'm 17 going
on 18. Life has changed so much for me since then.

Here is the beautiful, pathetic story of one of the greatest names in history. It is the story of a young peasant girl who heard voices calling upon her to deliver her beloved France from its English conquerers. So greatly did the French people love her, that although she failed in her mission and died a martyr's death, the memory of her short hour of glory carried her people on to ultimate victory.

Reprinted from "JOAN OF ARC",
Classic Comic Books, 1954

chapter 6
The Mask of the Actor

So many times in life one must put on an act. There are
so many situations where the true feeling must be
covered by a more acceptable one. As a child I learned
to don the mask when the occasion called for it. (Later I
learned to don the wig.)

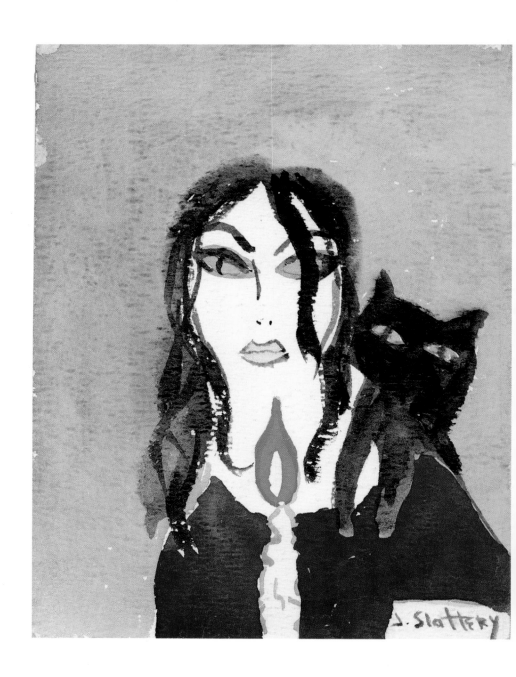

kim

Dear Jimmy,

How very pleased I am to know of
your genuine interest, and that it
exceeds just liking my films.....
that you not only believe in me, but
are concerned _for_ me. Thank you!

I'll be anxious to hear of the progress
you are making in the N.K.N.H....through
my sister Arlene.

Good luck and happiness be with you
always.

 Most sincerely,

KN:NN

Christmas—1965

Dear Kathy,

 Merry Christmas! I wish it were. Why can't I stop feeling sorry for myself? I am so lonely, Kathy. It's like I was in here. We must find a way to be together to help each other. I want to be at rest, at peace. I'm such a fucking self-imposed martyr. Everyone says I like to suffer. Why do I insist on being so unhappy? Please make me wise and make it snappy!

♥ ♥ ♥

I think I will become a nurse and help humanity and just go on like that, never giving a care for myself and become an old maid.

I am a star because I have always felt so alienated and I project this feeling to others.

I am a mutant

A woman without a man is a slave without a master

Your voice will thrill a nation

You oughta shine as brightly as Jupiter or Mars

You'd be more than Barrymore

You'd be terrific at RKO
Jane Russell would have to go

♥ ♥ ♥

A grief shared is half a grief

A joy shared is twice a joy

♥ ♥ ♥

One hopes that Carroll Baker is being well paid.

♥ ♥ ♥

Barbara Stanwyck just gambled her whole place away to
Ray Milland.

I try to get what I want whenever it's possible.

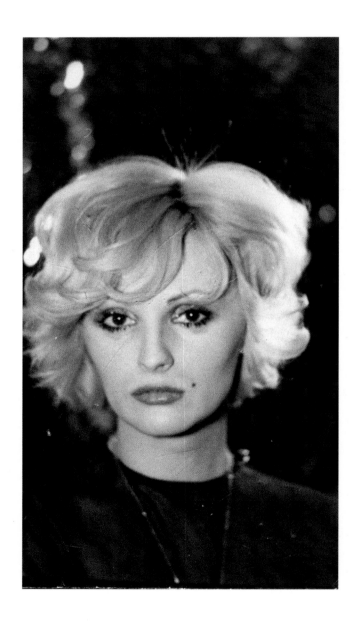

♥ ♥ ♥

I was stage struck when I was around 4.

I want to operate on the highest level I can operate on.

When I was a child, the kids always called me Marilyn or Greta.

Recently when I was at Merv Griffin's party a dyke came over to me and said, "Is your name Greta? You used to go to the Hayloft a few years ago and they used to call you 'the actress.'" So everybody knew even then.

I can get very Joan Crawford about the whole thing. Thanks for the punch in the nose. The Hydrophobia Hop is a dance where your dogs go wild.

He's got a lot of polish, he sells it after the show.

Why don't you keep your bee-stung mouth shut, ya little chatterbox?

Who does your material?
Your tailor?
It doesn't fit

Now darling, now please, I've come all this way down here from the Bronx on the B.M.T.

♥ ♥ ♥

Dear Kathy,

First of all, please forgive me for not writing sooner. I've been so involved with my own identity, which has been so vague, and social commitments, basic living procedures, and affairs of the heart that for awhile I ceased to exist. Except for other people.

Don't expect to see me for the holidays. I will not cease to be myself for foolish people, no matter how dear, for foolish people make harsh judgments on me that may hurt others that I love. As dear as certain members of the family are to me, I owe them nothing but what I feel for them. If what I feel for them is going to hurt me, then let it hurt me. Only the rejection will hurt. But it can never hurt me as much as I can hurt myself by not being myself. There is one thing I must tell you because I just found it to be a truth. I'm sure it must have come to you. You must always be yourself no matter what the price. It is the highest form of morality. We should both try to live it. You've got to always keep your heart and mind open. You can disguise your emotions, you can even numb them, and finally you can paralyze them. And that is tragic. Our emotions are the only clues to our identity. The only true meaning in life is passion. The passion to learn, to paint, to love, etc. Don't dare destroy your passion for the sake of others. When you do you've lost the beauty of life, and that's what a sin is. By robbing yourself of your very reason to exist, you have cheated. You must laugh when you must laugh, you must weep when you must weep, and you must love when you must love. I'm telling you this because we are in the same bag and also because I love you dearly. We are so close that you are actually a part

of me and that part can never be taken away. You are always inside me, in my memory and in my heart. We should do a lot of exploring together. I'd like you to come to New York to live with me. By January I should have enough money. It's time to live our own lives, and I hope we can enjoy a long, but not too long, relationship where we could share our room and board and ourselves. Hopingly presuming that we will both find lovers that will want us and need us to stay with them. As long as we have to grow up (and we really should, you know), let's do it together.

Love always

I have always found that social unacceptable people make the best lovers because they are more sensitive. Sandy spoke to me on the phone today and suggested a sex change.
TRICKY MOTHER NATURE

I can be happy and fulfilled, I will never doubt it. I can not afford to. Each thought Each moment tuned to some great moving force

They don't show love anymore in movies, just sex and violence. A man and a woman are no longer idealized in pictures but they are shown as a couple of dogs in heat.

What is it you wish?
I desire believing

Dear Yvonne,
 I happened to watch The Movie Game, on which you were a guest, Monday June 8. I was about to turn it off and do the dishes when I saw you were on the panel. I'll be honest, the first thought was, is she still beautiful? You were. I am glad to see your hair is still black and you wear a deep lipstick. I am only 22 and I'm somewhat of a celebrity myself. My name is Candy Darling and I am in Andy Warhol's *Flesh*, etc.
 The other women Edie and ————— looked awful in those atrocious clothes. Yours were not too hot either...you looked terribly top heavy. That jacket is awful, throw it out. You should <u>never</u> squint.
 The face and clothes don't go together. You see this beautiful woman's face and this big bush jacket. Have you ever tried Helena Rubinstein's face cream?

♥ ♥ ♥

It matters not what men see. For they see but what is put in front of them.

I couldn't show up at Genevieve's party last night at the Plaza. Who knows, maybe Michael Sarne would've used me. No wonder Jane Fonda or Hedy LaMarr wants to come to the factory, they don't want to see Holly. And everyone is sick to hear about Holly being nominated for an academy award. The idea! That she should be given an award just for being the slob that she really is. Andy, I saw her the other day at the Cookery. She had a beard with eye makeup on and a ripped sweater and ripped stockings and she was shaking like a leaf. She takes heroin and amphetamine and picks her nose in public. She has the vocabulary of a 10 yr. old. And the 3 outstanding stars got no awards. Viva, Brigit, and myself. Viva was the best thing you ever had. I'll never forget that picture of her helping your mother into the hospital. It was a profile shot and she looked like the most beautiful woman in the world. You can't really think she's great. You just want to put something over on the public. You just want everyone to say, oh well, if Andy Warhol thinks she's great she must be. Do you know she rushed over to Viva one day and said, oh Viva everyone tells me I look just like you and that I talk and act just like you. Viva told me and Geraldine that she was never so insulted in her life and she thought that Holly was the most ridiculous thing she had ever seen. Holly also thought she looked like Sharon Tate, this is when *Valley of the Dolls* came out, and just ask Jackie if you don't believe me.

When you first met me you said I had such good ideas but you never fixed my teeth. I know *Flesh* was sold for 400,000 and made plenty here in N.Y.

Dear Kathy,

I was glad to hear from you. I was in Toronto, Canada, on a publicity tour with Andy. It was so exciting. Did you see my picture in *Photoplay*? What? You didn't know? Yes my dear, your famous cousin has finally made page 5 of the January issue of our old bible. Remember how we used to pore over those fan magazines? Drooling over Liz and Kim—hating Debbie. Well now they can drool over me cause I'm famous and I'm beautiful! (In my 82 lbs. of makeup.)

I am so pissed. My manager called me tonight and told me about this new show "Applause". It's a musical version of "All About Eve" and it stars Lauren Bacall. Now my manager handles an actor named Tas Pengley. He's very handsome, like Gregory Peck, but he's a real conceited punk. He has an attitude like Laurence Harvey, asking me personal questions and acting so superior and snotty. Well, he has tickets for opening night. He was going to take Sandy but she can't go so she asked him to take me because it's a very Big opening. Now this fuck won't because he's too afraid of his image to be seen in public with me. He's afraid of being read for being a fag—well I can get very evil. I'll just <u>tell</u> everyone he's a fag. I can get very Joan Crawford about the whole thing. Anyway I shouldn't be acting like this.

Another frig in my life. My date for New Year's Eve. Jim Hanafy. Get a load of this. New Year's Eve I went out with Jim, Geraldine, and Leonard. When we were in the building where I live with my manager Sandy we asked the doorman to get us a cab. Now I can't tell him to give the doorman a tip, can I? He never sees that doorman but I'm always making him get me cabs. So I gave Jim a dollar to give to the doorman cause he's the man. Well when we got in the cab he still didn't give the doorman the dollar, he stuffed it in his pocket. I said give me

that dollar and rolled down the window and gave it to the doorman.

I just got over a terrific cold. I got it when we went to Canada. I think it was pneumonia or pleurisy because I was taking everything and couldn't get rid of it. You see, I went up to the frozen north in a micro-mini and a monkey fur jacket. Oh, and my other coat was a plastic trench coat. I bought one of those wet look coats it was $70. I hate it. When it's warm out the coat is warm when it's cold out the coat is cold. The monkey coat is glamorous but not warm. A friend of mine (Andrea Feldman) killed herself and she had a new black mink coat. I would like to buy it from the mother but I don't know her.

I found this great makeup for the lips. Max Factor's "Geminesse" tawny tint and with it Max Factor's lip gloss in the compact, but you need a lip brush.

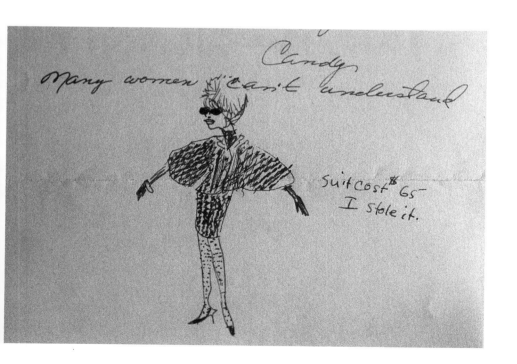

Anna - Fanny - Nanna - Quir -
Zanobia - Zanobia - Lenore -
Delita - Empress - Abdulla
Miranda - Mirandelle - Chiquita

Candy Darling *Mirandelle*

Candy Darling *Candy Darling*
Candy Darling *Candy Darling*
Candy Darling *Candy Darling*
Candy Darling *Candy Darling*
Candy Darling *Candy Darling*
Candy Darling *Candy Darling*
Candy Darling
Candy Darling
Candy Barbara
Candy Barbara
Candy Darling

My dear Pat,

I must say I am most surprised at not hearing from you in such a long period of time. I am very anxious to hear from you, please write immediately. You have been so good in the past, always sending such long letters full of news and photographs and I have always been the tardy one. It seems so unlike you that I sometimes wonder whether you are dead or alive. Since I have no way of knowing whether or not you will ever receive this letter I will keep it brief. Do you know that I sent a long very personal letter some months ago? I am very well and will have two films coming out soon. One is called "The Bar" (*called later "Some of My Best Friends Are..."*—*ed.*) It is a major film about homosexuals in a bar on Christmas Eve. I have a sizable part in which I am beat up and cry a lot. My name in the film is Karen and I wear all pink. It was one of the most enjoyable sequences of my life making that film. I have been in *The American Cinema*, *Vogue*, and right now I am in a film called *Brand X*, which is a satire of television. My name is on the movie marquee (at last!) I will send you a photo.

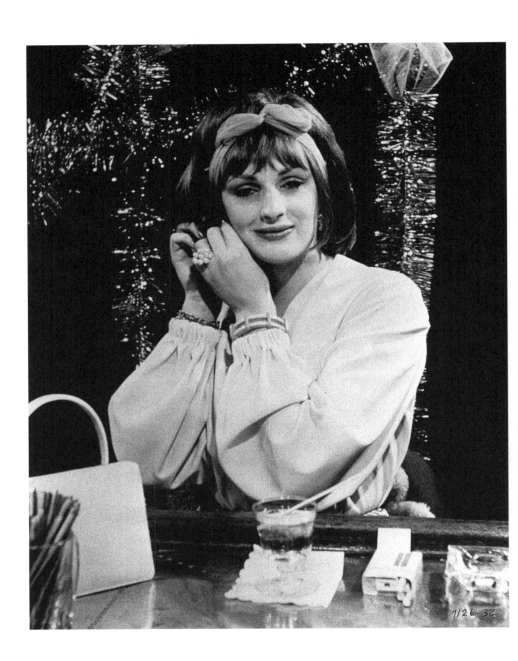

I must take the steps necessary to further my ability to function on the highest level I can operate on. I operate better as a woman.

I'd go in a burning building for you, if you fell overboard I'd jump in. 1/19/70

Be good, good, good, better, better, best, best, best you can be. Real, real, very real.
　　　Goodness sweetness simplicity
　　　　　　　　　all the things you are

My goal is to be a beautiful woman, rich and married by 1971. Sun. January 25, 1970
　　　I used 1 oz. hair lightener 1 oz. wintercheat 1 oz. ermine

I want to be good just to be good.

When depressed—
　　　Make yourself as pretty as possible.
　　　1. Get hair done.
　　　No money? Do it yourself—
　　　Do whatever you feel given to do.
　　　Clean.
　　　Visit Seymour.

♥ ♥ ♥

Candy by Candy

I want a taste of life
My own little war on being mediocre
unimportant and unsuccessful.

Learn to Sing

Let Someone with a deep love
give.

I never had anything make me this sick before
manhattans.
They were going to drive me into the city this morning.
1. a beautiful big house in Long Island and one in Calif.
2. learn languages & sew
3. Cabin on Lake Winnepesaskee

 Rug for my room — color T.V. fall — new clothes
white backless shoes. hormone treatment
electrolysis. dog. fur coat — car —
new house.

♥ ♥ ♥

To whom it may concern,

Dear Sir,
 This is just one letter to tell you how one person
enjoys and appreciates the Route 66 program you show
every weekday. The stories are so touching and
meaningful. The acting is so real and true to life. I never
knew how good this series was when it was on prime
time. God bless television. Without it many would
probably never see such great modern day stories. I am
an actress myself and I wish you could tell me how I
could find out where and how to obtain the script of

♥ ♥ ♥

Hi Tommy,

Surprised to hear from me? I never thought I'd be writing to you. I've been up all night alone, wondering about my identity. I'm living on East 6th St. now with a straight couple and a couple of drag queens. One of the queens triggered me off, trying to look for an explanation for living in this strange stylized sexuality. She asked me when she got in drag what I felt she looked like. Male or female. I tried to tell her there is no feeling about it. Realization cuts feeling off. I tried to explain my identity as being a male who has assumed the attitudes and somewhat the emotions of a female. I've been slowly strangling my ego. With the ego and fear I haven't many people to classify myself. The role is rather drab and without glamour and mystery. I don't know which role to play. I would like to live with someone whom I could—

♥ ♥ ♥

July Friday p.m. 1970

Today is Jim's birthday. I am on the Long Island R.R. on my way to see him. I am suffering again. Desperately desire lover. Want to please a man. Despise my body. Will appeal to God to help me.

What type of society is it that every malcontent is free to rear their ugly head and shout for rights?

date: Saturday July 8, 1970

condition of hair: very dirty, heavy regrowth in back of head, light regrowth in front. tangled, not smooth

material: ultra blue - starting at back right to back left to left side to right side. left on 1 hr. - result lemon color roots few black spots. Born Blonde beautiful beige. 30 mins.

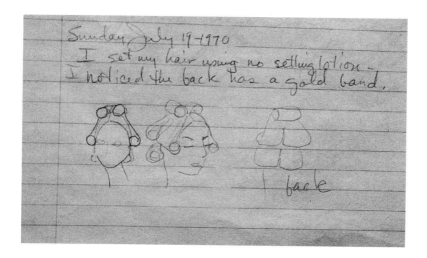

I will never break anyone's heart or hurt anyone's
feelings. I will be good and helpful to people around me.
I will work hard every day. Don't be a fool. Anyone can be
beautiful. At least anyone can have beautiful hair.

Always say and do whatever you feel but not
obnoxiously as some rebels do. Stand up for what you
believe in and do what you believe in. Be strong. Only a
lack of humility and truth can defeat me. —Be a perfect
angel.

The name you choose for yourself is more your own than
the name you're born with.

I am an irrestistible magnet with the power to attract
unto myself everything that I divinely desire, according
to my thoughts, feelings and mental pictures I
constantly entertain and radiate. I am the center of my
universe! I have the power to create whatever I wish.
I attract whatever I radiate. I attract whatever I mentally
choose and accept I am choosing accepting the highest
and best in life. I choose and accept health success and
happiness. I now choose lavish abundance for myself
and for all mankind. This is a rich friendly universe and
I dare to accept it for its riches its hospitality to enjoy
them now.

I dreamt of a nightclub with the atmosphere of a beach.
One wall a tide like an ocean, real sand, waiters dressed
like beach attendants.

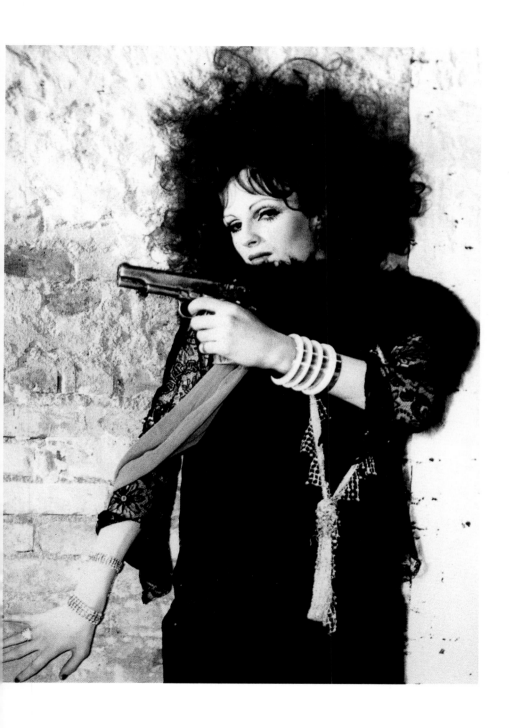

Dear Kathy,

It's Wednesday morning Dec. 16, 1970, 5:30 a.m. I got
up a little while ago. There is a storm outside. The wind
is very scary. Every morning I have coffee and cookies for
breakfast. I'm having it now. Thank you for the wind up
toy and it's always nice to receive a surprise. It's a good
thing you did not come to the party. I'm glad you didn't.
First of all, these unexpected people showed up and left
a boy there who was mentally retarded. Every time I
moved he would sit right next to me.

Jeremiah said, "Do you want to sit down in the next
room?" (knowing he was cookoo) and the boy said, "No,
I want to sit right here next to her" and every time I
looked at him he'd look away in shyness. Well we looked
in his wallet and found his name and address in
Connecticut and called his parents at 2 a.m. He had
been missing for two weeks (I was not surprised) and
said they were grateful and they would drive right down
and be at the apt. at 6 a.m. if it was all right with us.
Naturally we said yes and at about 6:30 a very normal
looking man with two sons appeared at the door and
was very appreciative. There were tears in the eyes. It
was very touching and Jeremiah even refused the $20
which the father pressed into his hand in gratitude
which will give you a clue to his character. (I do hope the
man didn't hear me whispering "keep it we need it")
Ha Ha.

Between the time we notified the parents and we unloaded him, another drama took place. At about 3 a.m. there was a beating at the door. When the door was opened, a Negro prostitute dripping with blood was seen. We took her in and gave her a seat. She had been stabbed in the head, or slashed or something, and was bleeding all over. I did not know what to do for the poor thing but I felt faint from the shock of it. Jeremiah again acted wisely and called the emergency squad. A few minutes later the police were there. My guests were absolutely mortified and most of them left (all the nice ones). Those who are amused by this sort of spectacle stayed to see what would happen next. Besides the two events mentioned, there were several heated arguments. One of my dear friends spit in another dear friend's face. I was not flattered when I saw the bathroom door had been beaten in and was lying on the floor. One girl had her clothes ripped off and fell on the bed in a flood of tears. There were, of course, the usual thefts (many of my presents), the animals had to go in hiding, Gary was yelling obscene things to people on the street, and Burt broke a bottle of bourbon on the kitchen floor. All in all it was a marvelous party dahling.

I was on television last Tuesday, you will be surprised to know. I did a song and dance and was interviewed.

Oh Kathy dig this. I was in Max's Kansas
City (the chic hang out for the jet set
of the world) earlier. This girl I know
came in and told me she found a
diamond bracelet in Le Club before
she came to Max's. She gave it to
the owner and I when I heard
this ran right to the phone and
called "Le Club" and informed them
that I left my diamond bracelet
there. I grabbed Burt but by the
time we got there the fuckin place
was closed. This is how I look now

Heather
rouge
from 5+10

Amber blonde

bottom lashes

Revlon
natural
wonder
lid shadows
cornflake
brown enough

Max factor
lip gloss

glams

glams

Au Rite

♥ ♥ ♥

There are men who are miserable creatures who only want to ogle girls and fulfill their own miserable lusts and then turn around and deny others like myself the right to have the most noble and worthwhile relationship with another.

I can survive without steak or even hamburger but not without love, integrity and idealism.

Candy's need for success is very strong and so the man I love would have to put his own work aside to help me reach for the brass ring of stardom.

I enjoy being a woman.

clean entire house

do legs

hang light fixture

candles

note book

noxema - very light

—learn apache dance—

♥ ♥ ♥

Night Club Act.

Life size glamour photos of me
Loretta Young theme song music
I appear in a flannel night gown in a bed.
Later the explanation
that I can't be real in an evening gown.

songs Getting to know you
 Have I stayed too long at the fair
 Mirror Mirror from Follies
 I'm Still Here

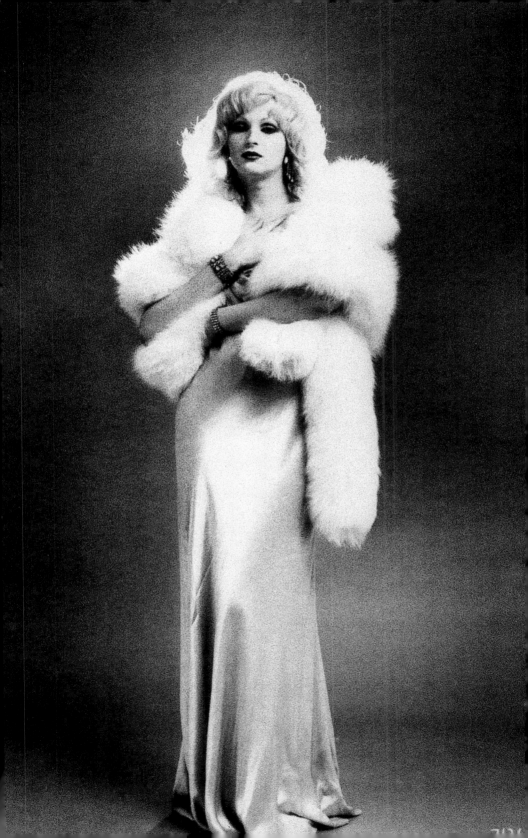

My name is Ronnie. I am very beautiful, spend a lot of time alone, and am very well respected. I collect beautiful clothes and pictures. No one is sure whether I am a girl or a boy.

♥ ♥ ♥

We heard recently that Candy Darling is so much in love with her newest hearthrob/amour, that she is seen kissing him all around town. She holds him so close that people often remark that he not only smells of her perfume but is frequently covered with her lipstick. We also heard that he was living with her in Sam Green's duplex penthouse. When asked how Sam feels about living with her "Ronnie," she unashamedly revealed Mr. Green is in India and doesn't know what it's like. Furthermore she pays for everything he eats and loves it. Everyone was dying to meet him until Candy called one afternoon and said she would arrive with Ronnie. Weren't we all surprised when Ronnie turned out to be a 9 week old Yorkshire Terrier pup, a gift from Candy herself. Speaking of lap dogs, although the exquisite blonde has been seen on a number of laps herself, she could hardly be referred to as a dog.

Ed

When I hold a little baby or a puppy in my arms, I know there must be some kind of God.

I dreamt that I was going to high school and I was in the hall on the telephone. I had Ronnie with me, who was only a little baby at the time and irresistible. He was in my parka asleep and I was talking to my grandmother long distance. These Negro boys came around me and were telling me to get off the phone and all saying I got to call my pussy and all crude things. I told them to just wait or go some where else and got into a little argument. They took my books and my parka with Ronnie and went outside. I got it back and when I went into the dark cafeteria to have lunch three other students joined me. I was telling this girl what happened and then I said where is Ronnie? I reached in my coat sleeve and brought out my hand with blood on it, which I thought was nail polish for a second because the thought of Ronnie bleeding in my coat was too awful. I reached in and brought him out. He was twisted backwards, wet with blood and silent, but still alive. I ran down the hall to the nurse's office. The apathetic students just sat there. When I got to the nurse's office I found the miserable bitch sitting down having her lunch. I showed Ronnie to her and begged her to help me, but she said she still had five minutes left of her lunch period and she was going to finish her tea first. At the same time I was talking to the innocent little dear broken in half. Please Ronnie don't die, I wish it were me instead of you. It was here that I awoke. Immediately I called Ronnie to me and covered him with kisses but he just chewed my fingers.

I'm being a lady and look what happens—all my clothes are gone.

Now that I am attractive to men there isn't a man I want.

Love is a delicate spirit that loses its essence under scrutiny.

What will I do in Italy to talk to people? They don't speak much English and my Italian is very limited. After I say pizza, mozzarella and lasagne there's going to be a big lull in the conversation.
Halloween is a long way off.

You're always apt to being the target of someone's bad joke. Or known to be unacceptable. Like you know you're never going to meet someone's mother.

help me to be less lonely.
Maureen O'Hara, *The Foxes of Harrow*

I think music can elevate the human spirit.

I ask for spiritual enlightenment
a husband—your choice
a career—utilizing wisdom
responsibility accepted

I would prefer to live in a more romantic age
when people danced together.

Call Viva get $ from Andy

I'd rather be a silly old fool than a lonely old woman
 you see
I don't think the sunrise is as good as the moonlight

Hip culture which has no grace
 The noble savage—turning to primitivism

Irregularity keeps you from really living.

People who talk too much and don't listen all have
a problem.

Tonight I met Laurie — transexual. She goes to Dr. Rich. He gave her the famous silicone bust, which she claims is much softer than the implants, but I forgot to ask her whether she was talking about the fat tissue implants, which is done in Germany. She said she has a job as a barmaid but didn't say where. She said she makes $2–250 — a week. Also she said she is having the operation in 6 mo. Tiffany was there too, who I think is really gorgeous. I still cannot decide about the nose job. The sex change and everything else yes yes yes.

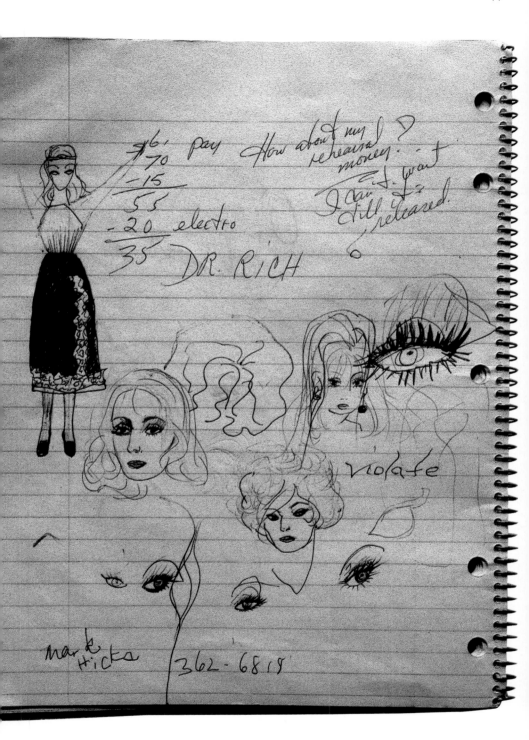

$6. pay
70
-15
55
-20 electro
35 DR. RICH

How about my
rehearsal?
money.

I can't wait
till its
released.

violate

mark
ticks 362-6815

If I am going to be a woman, I want the whole thing: a home in the suburbs, a husband, and strange as it may sound, children.

I have just spoken to Taffy. She called me. I told her that I saw Anita Ekberg on television in a movie called "Screaming Mimi". I told her how beautiful and alluring Miss Ekberg was and perhaps that is what we all want to be. Taffy said that she is in analysis and no longer thinks she is a woman and perhaps she should be a man. Bob (her lover) has already said he would accept her that way. She said it may take 3 years, but it is better than what she has this way. She said the reason we are the way we are is that we did not have suitable male identities when we were growing up. And just because we did not have suitable identities is no reason for us to think we are women. Perhaps she is right. She says it is $30 per visit and it would help. Maybe God is speaking to me through Taffy. I am going to go to the premier of *Barbara* tonight. It will probably be just a meaningless bore. I hope if it is, I can visit Carlos and get him to get me that coat!

I also spoke to Ron Link today (I called him) and he said to forget the play, that it was not enough time.

I am right now on the train on my way to N.Y. to the premier of *Barbara*. I will get to N.Y. Penn. Sta. in just enought time to take the subway downtown to the Garrick Theatre on Bleecker St., just in time for the end. Well maybe there'll be a party afterward. My upper lip is all bumpy, I hope no one notices it. I feel I am rather through with men. Love of God will replace love of men, and actually I don't feel I need a man. I don't hate them or anything. I see men and sometimes I feel if I were to have a man I would like one like that. But I have no longings or crushes or anything. And yet maybe I'm always hoping.

leaping to conclusions - what else is there to leap at except men.
One keeps me in condition for another.

I know it hasn't all been beer and pretzels for you either.
 Lilli Lilli Lilli
 personal considerations
 sunburned psuedo virile types
 they get a girl all confused then leave her that way

I have always been the goddess above it all, untouchable.
I explain my influence over men as simply this. I represent to many
men a goddess who is untouchable, and yet a goddess who needs
him to make her happy. I was born to be a queen and every time I
come down from the throne I am humiliated for it and suffer many
indignities.

This is my barbed wire dress. It protects the property
but doesn't hide the view.

Money doesn't buy everything but it does buy some nice goodies—

He's a very handsome man.
I wouldn't have anything else but.

Welcome to the Ponderosa
No, it's the White House but the President is out demonstrating.

Yes it is up to me. That's kind of nice to say. It's up to me.

If you ever do progress to a higher level of human awareness,
Stay there and do not ever come down. Think not to glorify the self
but the great schemer. Seek no approval or applause from man.

Where were you
Him—out. Her—out where. Him—look just leave me
alone—she slaps him they <u>fight</u>! He beats her she runs
into bedroom falls on bed crying. After she's all cried out
she very composed gets up slowly very dignified and
walks calmly out of the room.

Dec.
I just finished doing my hair. I bleached it this morning
(again I didn't leave it on long enough) and I used
balsam and Roux white minx rinse. I'm going to let it dry
partly and reapply it. Yesterday in the mail I received a
letter and wind up toy from Kathy.

There exists a whole subculture of people that are movie
star oriented. There are many women who try to look like
Elizabeth Taylor, Kim Novak, Veronica Lake, Jackie O.

♥ ♥ ♥

You shouldn't look so disapproving, Lavinia. It makes
you look older and age will come soon enough to
destroy that pretty face. A thing of beauty cannot remain
so forever.

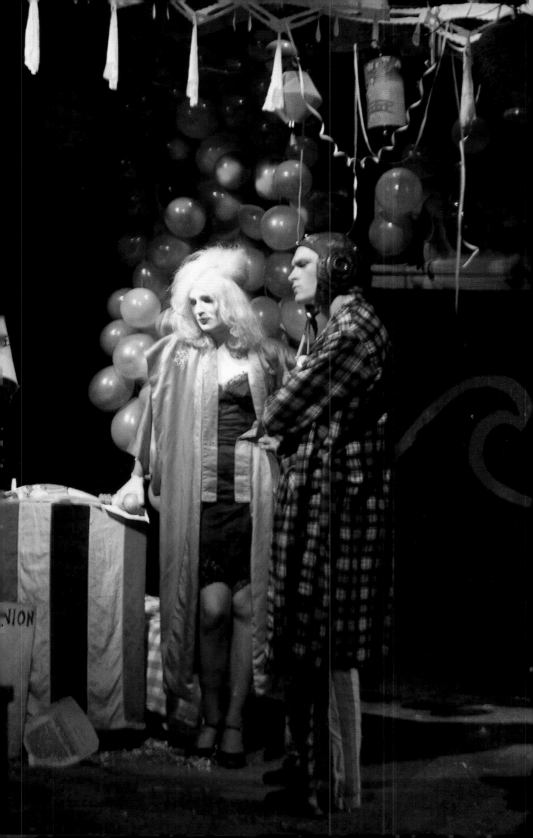

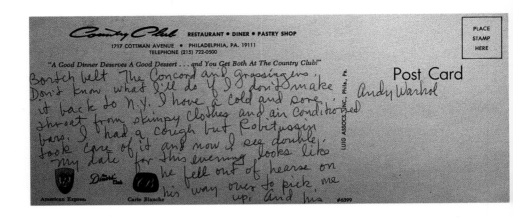

Borstch belt The Concord and Grossingers.
Don't know what I'll do if I don't make
it back to N.Y. I have a cold and sore
throat from skimpy clothes and air conditioned
bars. I had a cough but Robitussin
took care of it and now I see double.
My date for this evening looks like
he fell out of hearse on
his way over to pick me
up. And his

Andy Warhol

I'm a thousand different people. Every one is real.

> The Moments
> Love on a Two
> Way Street

Mother,
> Will you wake me up before you leave?

I need time. I've got to figure out what I am.

Candy Darling Candy Darling
> Candy Darling

> the manner in which you
> answer the question and
> not the specific answer

Broad road to destruction.
Do not allow the mind to be affected
by the world.
Human nature motivated by sin.
Opposition to God is bound to be punished
Following Godly will cost you
1. Repent 2. have faith 3. Obey

Dear Niel,

It was so nice to hear from you. I'm glad to see you are doing well. Everyone from Mervyn's class is doing well. That's because they are all so good (not as actors, as souls). Dana I know is in Japan giving the oriental populace a few thrills. Perhaps right now some suave Japanese man is showing Dana his junk. Some actors are so desperate to reach their goal that they never make it. I mean they reach their goal in the acting profession but never make it as people.

Tell Maria I said hello. Has anyone else over there even heard of me? By the way, I am in Jan. & Feb. *Photoplay*, Dec. *Esquire*, Dec. *Nova*, and the March issue of *Vogue*! I know I'm destined for stardom because when I walk along the street I sometimes see people staring at me and pointing. And the other day I overheard one woman saying to some man "I know where she belongs!" Also while uptown on a bus I had a tremendous black velvet slouch hat on, a trench coat, (knotted around the waist), and large dark glasses with aurora borealis trim, and when I put the two dimes in the machine the bus driver called me back and said "It's thirty cents Greta." Around the village I'm affectionately known as "the actress". My friends have many pet names for me, like Marlene D-Train to Queens, Mamie Van Doorway or Diana Doorways. Instead of Audrey Hepburn, Tawdry Heartburn, Tana Lerner. All of these things combined (last week I went to IFA and was so glamorous that I overheard a man in the outer room gasp out loud). Also the receptionist told the agent I was trying to see that "this one must be seen to be believed."

Candy Darling is the worst woman in the world

<div align="right">as MYRA</div>

Oh you Beautiful Doll

When I went into the beauty shop Cinandre the other day I went into the room to change into a smock and forgot which side to wrap it to.

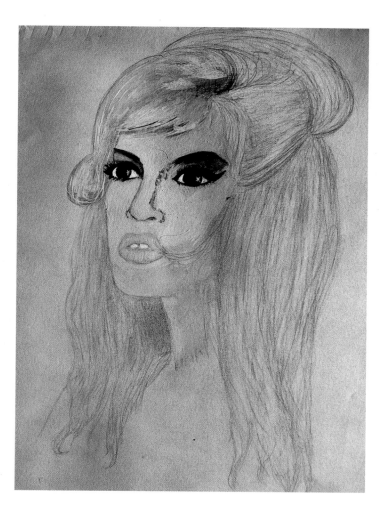

All of the protests imbued with political views and social criticism that I am usually made to feel embarrassed by my lack of knowledge. I am used to watching television with my friend who is a U.N. diplomat and having him explain it all to me. Sometimes I may disagree on a point but I feel that he knows better than me. I'm not saying that all women should be like me. I'm just saying that my intention or guardian angel or whatever that steered me to a right thinking man steers me right away from Betty Friedan and Gloria Steinem. They both come across very hard to me and I don't like hardness, especially in women. I've seen a certain hardness in certain men like Robin at Max's K.C., but it's a hardness that only covers up something good and gentle and I find that most exciting. But it is my opinion that Betty and Gloria are hard all the way down right to the bone marrow. That Betty has a purpose; I don't know what it is but I have my suspicions. (I can't forget the visual image of her standing on a platform in Bryant Park like a field marshal). I would chicken out on a real debate with her. It would take a man to stand up to her. I see the day coming when the words femme and butch will be more commonly used. I mean to be used for heterosexuals not just gay or bisexual. Think of the interesting types.

Female—Heterosexual—type—
Basic Butch—the drag type with
femme overtones.
Raq. W. / J. Craw. / Jane Russell

Basic femme — Butch overtones
Greta Garbo

Basic femme — femme overtones
M.M. — L.T.

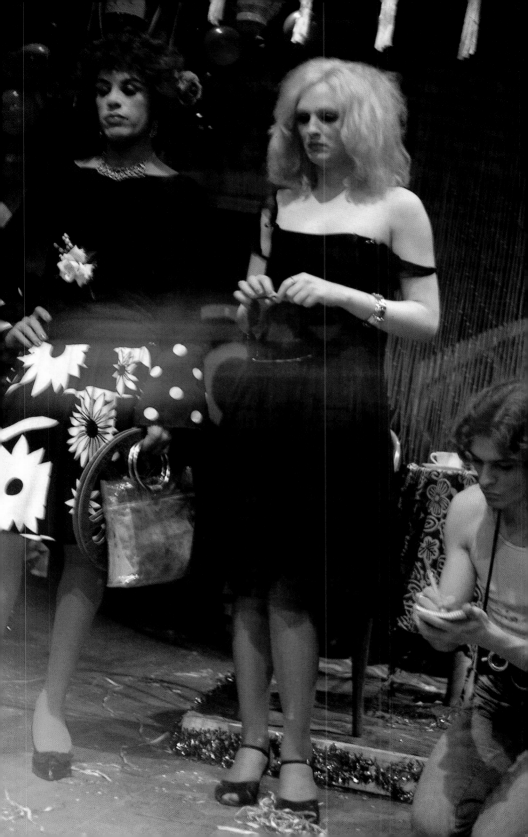

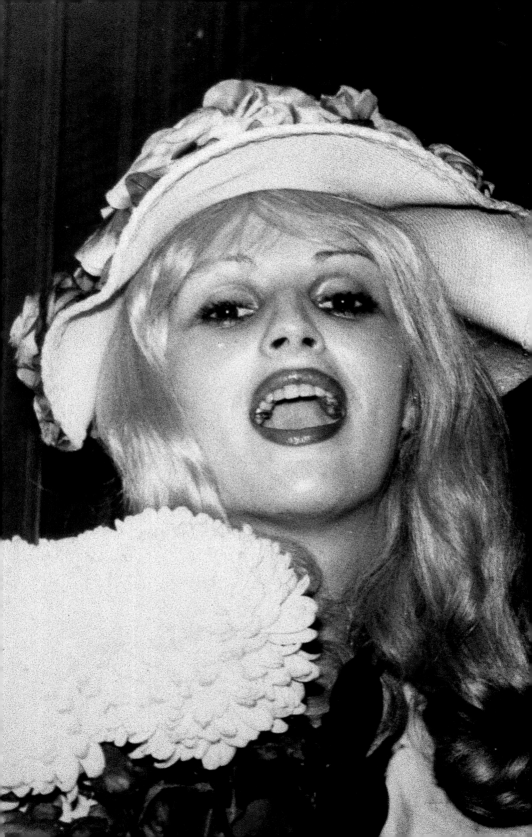

Relax you'll tear my dress.
So what I paid for it.

Why does everyone dislike you so much? Because they're all a
bunch of phoneys. Even if they are all a bunch of the phoniest
bastards in the world why do they all not like you? Whether
they are or not, to strike fear in people is not a good thing to do
and you will one day be sorry you ever did this. To argue a point
with you is useless, you never give in and I know you feel this is
your forte. Remember, you may win the argument and get the
better of someone, but you lose a friend and create a feeling of
bitter resentment.

 If you're so goddamned smart, did you know that your good
friend that blonde German made 13 television shows over in
Germany and I'm in practically every one of them. And *Flesh* is
the biggest movie going over there and they (the Germans)
asked for the stars to come over and Paul took Joe, Geraldine,
and Jane Forth on a tour with *Flesh*. Jane didn't have to go. Why
should Jane go? Paul doesn't even like her, he calls her that
dumb thing, misery and Baby Biafra. But she's so cooperative
and does whatever they tell her. Why didn't you get in touch
with Bert? Now they're going to promote Holly. Can you believe
that? They're sending Holly to all the photographers. She went
to this big party with George Plimpton and Tammy Grimes.
She's in the Times and I'm the forgotten woman. George asked
why I wasn't being taken to Europe and Paul said "too much
trouble, too too much trouble. Sandy'll be up here and she'll
want to go and then they'll be another fight. She has bad
vibrations." Don't ever think you're going to work for Tom Ward
Agency because you never will. That's when you started treating
me like a piece of shit. You thought you were going to have a
big important job.

Sunday August 29, 1971

Love is not for you yet. Work, be real, follow your intuition, spend time alone to learn truth. Be wise. The only real thing is to be alone and do your work. Be very careful about every move you make. The future depends on the present. Read this over every morning and add to it when you want. I must honestly say that I believe I am here for a life of suffering, sorrow, and longing and not to have it relieved until my death. Always have 5 dimes. And every telephone number. My heart is broken. I don't believe he wants my love, that's what I want, that's what I need. That's what I long for. That's what I've never had and am afraid will not get. Will my life just be a torture test of endurance? To not be able to have what you love is the most bitter pill to swallow. But I hear that if you can learn to love God he will always be with you and you will not need human love.

Human love, that's a good title for a picture. Whatever I get I can dedicate my life to beauty, love, and goodness. If God will give me my love, I will promise to always follow his guidance. Maybe Richard does love me. Maybe he thinks I don't love him because I didn't go to the movie with him and Paul Ambrose last night. I will try again. After all, he's sensitive too. He kissed me on the back of my neck. He sang in my ear. He said something to the effect of falling in love at the party. It's my consciousness that needs to be raised. Yet still I believe it cannot be. Am I in hell?

Monday, August 30, same time

I feel much better. Tonight I must pray for Chuck's love to come to him.

♥ ♥ ♥

I don't mind that little smile around a person's face
when they talk about me.

Look for meaning.

Sermonette

♥ ♥ ♥

I was always and still am to many who knew me, family,
school mates, friends, an inferior (inadequate) person.
In a second-class position. This is not to say that I was
unable to draw affection, and even respect, but the
affection was mingled with sympathy. The respect was
given me because of my aloofness.

I feel like I'm living in a prison. There are so many
things I may not experience. I cannot go swimming, can't
visit relatives, can't go out without makeup, can't wear
certain clothes, can't have a boy friend, can't get a job. I
see so much of life I can not have. I am living in a
veritable prison.

It took place here in the house. Tryon was here spouting words of wisdom. I had been married to Elvis Presley. Larry S. was here, and Owen. Lightning was near. I came into the kitchen & saw Tryon taking money out of my mother's drawer. I asked him what he was doing and he said it was a magic trick. Lightning struck the house. I ran into the bedroom. When I came out, Owen & Tryon were gone. I put on a black hat like Robin Hood and pancake makeup and followed him in the storm. He took a lot of money & left only a $10 bill.

Roux $^1/_4$ oz 18 - $^1/_4$ - 42 $^1/_2$
peroxide
 rapid hair lightener
Permanent color
 5-50% grey select exact color and leave on 25 minutes to
 match natural color
To brighten natural color select 1-2 shades lighter and leave on
25 min. only.
 For maximum brightness—
 select desired shade & leave on 45 minutes. The lighter
 the color used the greater the lightening action.
 For more than 50% leave color on 45 minutes.
 For more than 50% for lightening & brightening grey
 select 1 to 2 shades lighter
 Leave hair around 6
 Virgin head leave fine hairs and ends until job is
 completed... leave 25 minutes keep it wet.
 French Fluff 1 oz., oil bleach, 3 oz. peroxide, 3 oz.
 shampoo
 Glamour bath. 1 oz. tint, 3 oz. peroxide, 3 oz. shampoo

Last night I saw a fabulous movie with Ginger Rogers, Doris Day (ugh!) Ronald Reagan, & Steve Conchran. It was called *Storm Warning* and they whipped Ginger Rogers, Yeah! She was a witness to a murder by the Klu Klux Klan and Doris Day's husband Steve Conchran found out what she knew so he called the other members & they took Ginger to a big rally and two men held her and another whipped her. HA HA HA. Serves the dirty wench right. Then Ginger's sister Doris Day arrived with Ronald Reagan (the district attorney) and the dope thought she was going to stop all these thousands of Klu Klux Klan members. (The bleach must be going to her brain.) Anyway she got shot right in the gut by her own husband, that's what made it so fabulous.

79 First Ave.

Massapequa Pk.

New York 11762

Dear Werner...

I just finished watching *The Damned* and it reminded
me to write to you. It is right that I do not write to you in
so long. You probably do not want to hear from me
anyway. Paul Morrissey told me when he met you in
Munich he got the impression you were not very pleased
by my performance. I was sorry to hear this. I do not
know why people use me at such great expense. I don't
think I'm as good on film as on stage. I am like Candy
Bergen. The two Candys are just alike.

anyway he is a troublemaker

♥ ♥ ♥

I dreamed that some woman, a youngish looking
woman, Lee Grant, was driving me to a hospital. There I
saw Ron Glick, who had become rather deranged but
was still attractive. The woman turned out to be his
mother. He didn't recognize me immediately. I said
"Remember me? Candy Darling from Andy Warhol's
factory." He put his arms around me and was laughing,
when his mother was leaving he asked me to stay. I did.
We realized that we loved each other. He begged me not
to leave; I said I never would.

Dear Mrs. Vreeland,

I understand from Sam Green that you are interested in movie stars of the 1940s. Since I have spent the majority of my waking time watching old films on television, Mr. Green feels I should be by now an expert. I have divided these players into 5 categories.

Leading Ladies, Sultry Sirens, Ingenues

LL Mary Astor - matronly, aristocratic

SS Evelyn Ankers - A lead in B horror films

Jean Arthur - big star, comedienne & actress of the highest calibre

June Allyson

Lucille Ball - comedienne, actress

Lynn Bari - snobby, suitable for other women

Viviane Blaine - musical comedy

Joan Bennett - supreme actress & beauty

Joan Blondell

Ingrid Bergman - serious type

Talullah Bankhead - a true great

Joan Caulfield - big-boned blonde

Jean Crain - young, delicate, & sweet, very beautiful

Claudette Colbert

Joan Crawford

Bette Davis

Linda Darnell - dark beauty

Olivia de Havilland

Yvonne de Carlo

Marlene Dietrich

Joan Fontaine

Alice Fay

Jane Frizee

Greta Garbo

Judy Garland

Greer Garson - heroic

Paulette Goddard - spunky

Betty Grable

Rita Hayworth

Betty Hutton

Ruth Hussey

Katherine Hepburn

Susan Hayward

June Haver

Jennifer Jones - glamorous in white fox

Adele Jergens

Hedy La Marr

Carole Landis

Ida Lupino

Veronica Lake

Marie McDonald

Maria Montez

Marian Martin

Mary Martin

D. McGuire

Character Actors

Natalie Schafer	Donald Duck
Jane Darwell	Mickey Mouse
Cecil Kellaway	Charles Coburn
Walter Brennan	Judith Anderson
Charles Laughton	Charlotte Greenwood
Clifton Webb	Ethel Barrymore
Edward G. Robinson	Spring Byington
Billie Burke	Butterfly McQueen
Monty Wooley	Hattie McDonalds

Juvenile Stars

Roddy McDowell	(special award oscar)
*Natalie Wood	*Mickey Rooney?
*Elizabeth Taylor	*Judy Garland
*Jane Powell	Deanna Durbin
Shirley Temple	Skip Homier
*Jennifer Jones	Dwayne Hickman
*Margaret O'Brien	*Peggy Ann Garner

also discovered in late 40's

Arlene Dahl - Tony Curtis

Ava Gardner - Janet Leigh

Shelley Winters - Debbie Reynolds

English Imports

Vivien Leigh, Laurence Olivier

Jean Simmons, James Mason

Deborah Kerr, Merle Oberon

Greer Garson, Stewart Granger

Bob Hope, Lily Palmer

People you love to hate
Strange Ones & specialists

Vincent Price - Boris Karloff - John Carradine

Bela Lugosi, Sydney Greenstreet,

Gale Sondergard, Peter Lorre

Mae West, Sonja Henie

Mercedes McCambridge

Gene Autry, Roy Rogers & Dale Evans

Lon Chaney, William Boyd (Hop)

The Metropolitan Museum of Art

New York, January 4, 1973

Dear Candy Darling,

Before Christmas you wrote me a marvelous letter
defining very carefully the ebb and flow of the
glorious 40's. You have made all so clear, defined
all so well and I am very, very much obliged to
you for having taken this trouble. The letter is
of the greatest value.

I want to thank you very, very much indeed. I
hope that one day we will meet because we haven't
really and I want to wish you a very happy New
Year. I hope your dreams will be fulfilled.

Very sincerely yours,

Diana Vreeland

Candy Darling
c/o Samuel Adams Green
14 West 68th Street
New York, New York 10023

For *Vogue*

Whenever I get tired of getting made up and I feel blah and wearing dark glasses and just withdrawing in general, I do just that, I take a day and do whatever I want. Read, go to a movie, rest, watch T.V., and eat. Go to the A&P and buy everything, come home and eat it. Visit a friend, go shopping, in general get "revitalized."

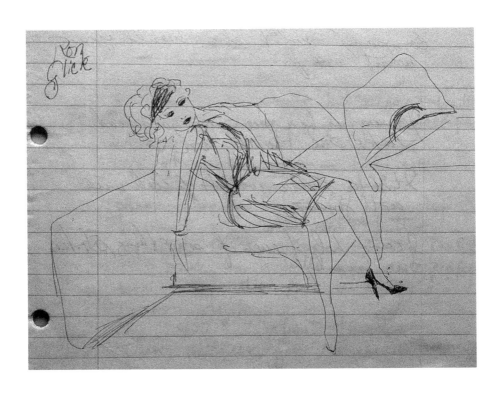

No romance in my life, so I feel it is best that he does not call. Even though I long to be loved by a man, I know it cannot be. I must live without love. It is the cross I must bear. I must accept what is.

I think I see a place where I could use a silicone injection above the upper lip and near the nose.

♥ ♥ ♥

The Greta Garbo Home for Wayward Girls

I'll be waiting in the other room, you'll recognize me. Just look for the blonde on the divan. I'll be wearing a warm heart in my left lapel.

You are what you Eat Salad

1 head lettuce (iceburg or romaine)
2 sliced tomatoes
anchovies
$1/2$ cup walnuts
separate 3 egg whites
use yolks
whip yolks
2 T olive oil
whip
$1/2$ t dry mustard
$1/2$ oregano
wee bit of lemon - now work it
add a flurry of salt

Tonight I met a boy who wants to be my slave. He calls me goddess. Kathy, I don't think you can understand these things. You are so simple and I so jaded—not really worldly, let's say.

You will be surprised to know that Jane Fonda's husband Roger Vadim, who was married to Brigitte Bardot, is in love with me. I was out with him last night. He told me he loved me so much that he would fight a war for me. I gave him a silver ring with a turquoise. He kisses me and holds me in public because he is truly innocent and cares not what people think. I always feel I have to protect him. We have not been to bed together.

Last night was the last night of my two week play and at the end I changed it around. I played a woman who invited her ex-family over for a reunion. It was called "The Reunion". Her family did not like her because she is mad. I felt the play lacked sufficient drama and did not allow me to show everyone what I am capable of doing, so because it was the last night and because Vadim was there, I changed the ending. I went into a long monologue, laughing, screaming, and crying. When the writer (who is also the director and also works the lights) saw this, he turned out the lights but I kept on, even on a black stage! Actually it wasn't even a stage, it was the back room of a bar on East 3rd St. called the Old Reliable. After the show everyone was coming over to meet Vadim. I didn't know how to act, because when average people meet someone who is famous they think that they can turn over their problems. Even the owner of the bar was telling Vadim

of his problems, how he'd like to have a bigger place, etc. But Vadim has this quality of being like a savior. And I know I have a look of refinement and nobility which is sometimes thought of as being angelic and ethereal. Perhaps people think my touch will heal them. Why must I be deified? It is such a burden. I don't know what else to say, I better end this letter. Be sure never to throw my letters away but put them in a safe place as someday they are sure to be worth money, and it will be your good fortune to be prudent now. Besides, I may wish to look them over myself someday when I write my memoirs. When will your telephone work? Would you like me to visit sometime? I would love to come with my manager, Sandy, or a boy friend. Yes, in spite of all the places I've been I'm still not able to take care of myself. Write to me soon, I'm sorry for the delay.

<div style="text-align: right">

Love

Candy

</div>

♥ ♥ ♥

Dear Kathy,

Please tell me why you haven't written to me by now. I mailed you a letter some time ago and it is not like you not to write. Didn't you get my letter? I would be absolutely sick over it, so don't lie. I wrote all about my affair with Roger Vadim, Jane Fonda's husband. I will die if you didn't get that letter. I was in *Vogue* March 1 and March 16.

— Peter Fonda —

Jane Fonda 265-1682 2 weeks

Hilary Holden

1733 Broadway. 123A

— a Safe Place —

— Teacher —

parenteral use Scherings Estinyl
 Premarin (Ayerst) or Amnestrogen
 5 mg. daily

Estrogen principle female harmone
 add progesterone
Stilbestrol — breast
 Squibb's Delestrogen, slow absorbing,
well tolerated — dosage 20 to 60 mg.
½ to 1½ cc usually 30 to 60 mg.
of Delalatin
 Delestrec

It's never been done, photograph
my face and Duncan's as
if in orgasm!

What do you mean I'm not alluring enough, maybe my name isn't Tondelaya but I've brushed off more men than the porter at the Waldorf.

There are people that wanna <u>be</u> that can't <u>be</u> so they put something on so they can.

I already know a lot of people and until one of them dies I couldn't possibly know anyone else.

Everyone needs some portion of Leadership. Look for opportunities to be of service. Set definite goals—plan purpose and strive to be the best thing you can be
 weigh the consequences
Conscientious leadership spreads divine light and love. Be patient—wait for the right time. Temptation to quit and take it easy.
inspiration
ask holy spirit to breathe into you
Do what you can because there are many things that need doing.

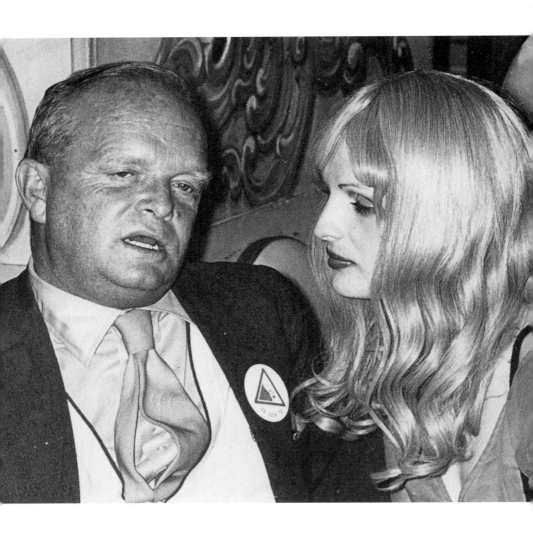

...that promised to be a long and rewarding
...career fizzle out into disillusionment

...once popular off. off Broadway and
underground Star seeks work
...ntact Candy Darling
...he once popular underground
...screen godess.
...the ex-denizen of glamour.
It Hurts to Be A Has Been
a fallen Star

Curt Junger

THE NATIONAL SHAKESPEARE COMPANY
414 WEST 51 STREET, NEW YORK, N. Y. 10019

Maybe by the time my nails are a decent ladylike length I will be rehearsing for a play, maybe the one Jeremiah and Burt are writing for me (if it's any good). I like the title, "Camille's Cough". Do not know what is happening for Thanksgiving. It snowed, so Warren and Mary Ann did not come down. I am going to call Senator Halpern tomorrow for my mother. I told my mother I want Diana (Burt's sister) to come and live with us if I get a show. She can be my maid and companion. Please God if you hear me, grant this wish. Jerry Bradley wants to help me with a nightclub act. Luciano says I can open in the back room of his bar. Jeremiah said Eileen thought I was so beautiful.

It is now November 24 about 4:00 a.m. Today is my birthday and I am happy. Ron Link called me and told me that Jackie did not show up at Ron Delsener's office. I want to do "Glamour Glory & Gold" more than anything. I will have to wait around Max's some night until Jackie comes in and bargain with it. My nails were completely bitten to the quick last night and I have promised myself that I will never pick or bite my nails again and from now on I will apply RRP nail conditioner every night. Tomorrow I will have to wax my arms. Jeremiah is such a dear, he called and wants to have a party for me. I hope we are friends forever.

I am not a genuine woman but I am not interested in genuineness. I'm interested in the product of being a woman and how qualified I am. The product of the system is what is important. If the product fails, then the system is not good. What can I do to help me live in this life? I shouldn't be disturbed all the time. The main thing is will. I benefit by it.

NOEL

all me Think here is how to line. Janette

Saturday June 3, 1972 8 p.m.

Steven is here. Last night I went to the Everything is Everything ball. It was fabulous. I met a lesbian who was tall, strong, and beautiful. There was a model there who was so beautiful she made me look like a frog. It's all so unreal. I met a man there English Taylor introduced me to worth 20 million, but Taylor exaggerates. He said I was so beautiful it was staggering. He finally left and I was left with the lesbian. She was marvelous, she looked like a young boy. I became very depressed I couldn't get the guy I wanted. I am filled with frustration and anxiety. Last night I prayed I would die and pictured myself in a coffin having the lid slammed down shut, thrown in a grave and dirt thrown on top and a steam roller going over my grave. I feel that hopeless and forsaken. I'd do anything for the right lover but I guess I don't do the right things. I received some pictures in the mail today from A.I.P. I looked just awful. I do want to get my nose done and electrolysis. I have to go to Gertz to buy the perma-tweez. I'll try it, I hope it works. I don't think I want to be a woman anymore, I can't be. I'm too strong. I think when I come back from France I'll go to another city like San Francisco or something and live as something else, but a creme puff I'm not. There is a strong side to me. I want to be like Terry. No more mistakes though, and no more laziness. I've got things to do and I won't rest until they're done. I don't have to act like a woman or a man, just be myself. Maybe I'll go through primal therapy.

My father just called. I told him of my plans to go to Paris. He said, "Don't be too easy." I think he's right. In closing he said, "Good luck Jim." From now on maybe it would be best to live as a robot for other people and not look for self gratification and self glorification. I do have feelings for other people and it should make me happy to make others happy, but I'm very sure that there is no love or personal happiness for me in this world, this is an incarnation where I must work it out to make up for the past and provide for the future. Today was caused by the past and the future depends on today.

I just saw a picture with Aldo Ray when he was young. What a hunk of man. I'd love to have a man like that—<u>tonight</u>! I feel like getting dressed up and going out looking for a man. I mean I'm desperate.

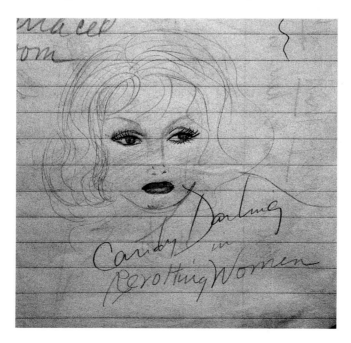

I'm in hot water if she ever finds this letter. I am going to pray so not to see this person anymore. Last night she wore striped bell bottom pants with white go-go boots that had bells on them. These boots are so designed that they are suitable only for a short dress. They're the kind that are cut out in the front and have a bow. Also a silver leather coat with a belt from the early '50s. Are you getting the picture? Isn't this beauty? A green tiny head band scarf with white polka dots. A leather beatnik pocketbook. She looks like a walking junk shop.

♥ ♥ ♥

I don't like to go out with people who do not feel they are my social equals. People that are too nice to me. Tonight I went out with Jeremiah and his friend whatsisname. Jerry met me at Lincoln Center and we had a drink (Irish coffee) at a bar. Then we went back to Lincoln Center (the fountain) and met whatsisname. Then we walked over to take the bus on Broadway and who did go riding by on a bicycle but Bradford Riley. We were programmed to meet, I know it. I knew I would meet him today. Because I am wearing the black skirt and printed blouse. It is the 3rd time he has seen it. The last time was at the premiere of *Barbara*. The time before was the play *Arresties*.

To think I once loved him. I am sitting next to a primitive and there is one sitting across from me. I hate riding with scum and that's just what they are: hard faces and they both have their feet up. Naturally they are scrutinizing me with their hard eyes and talking childish voices. Do I still love Brad? I don't think so, but I do like him as much as I can like any man who is that attractive to me. If he were mine I'm sure I would wear him as proudly as a diamond brooch. I told him to call me.

It is 10 P.M. I am waiting for a phone call from a taxi cab driver I met last night. He was young and very beautiful. I hope he doesn't call. He knew who I was, having seen me on television. He drove us uptown to 42nd street where I dropped Andy Milligan off. Then he took me uptown to 77th between Madison and 5th Ave. where I went to visit Jim and Leonard, I told him (David Spalding) I lived there and gave him the telephone number. I also told him I would be on L.I. and gave him the telephone number here. I told him to call at 10 or 10:30.

As a girl you're entitled to certain hopes, certain needs. You have a right to expect that there will be a special place for you. These feelings are luxuries to me.

Hi Dear,

How are you? I have a new secretary—his name is George. He's only 18 years old but very wise. My hair is butter blonde and I have a Carroll Baker look. I love Carroll Baker, don't you? Doesn't everybody? Who doesn't?

I sure wish we all could get together this summer. Remember that loveable cottage on Lake Winnepesaukee? I still remember the people's name— Horn. It would be just so wonderful if we all could rent it for a week, you and Bob, George and I. What do you think? It's so private and such a beautiful lake. Don't worry about George, he does what <u>I tell him</u>! Just like Joan Crawford in *Queen Bee*. In *Mildred Pierce*, in *Harriet Craig*. George and I love Joan Crawford. We saw her in a film called *Berserk*! It was supposed to be a horror film but it was really a laugh riot. Joan owned a circus this time and all these performers were getting killed in gruesome ways. Diana Dors was in it and she was sawed in half. You remember Diana Dors, don't you? England's answer to Jayne Mansfield? Oh, you remember, a real cheap looking tomato with a tremendous bust, platinumized hair, big lips, a hard trashy face. She got hers the day after she was discovered in Joan's boyfriend's trailer, portrayed by some young stud type. Oh, it's a real must-see.

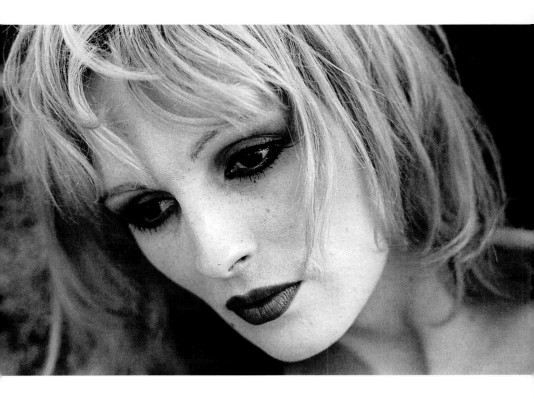

This, I hope, will amuse George.

I'll never forget the night Sandy, George, and I came home from the Sanctuary. When I asked her if I could stay over with George, she said she didn't know where we would all sleep as Gil Gerard was staying over. What can I say? I was stunned. Gil was one of the most gorgeous studs on the set. I mean real A-1 top quality grade A male flesh. I hoped to God he wasn't sleeping the bed but on the sofa. My highest hope was that perhaps since we were coming in so late he would make an excuse to leave early and get dressed and get out. But my hopes were not realized. When we arrived at the apartment somewhere around 6 a.m., Sandy rang the bell cursing him and saying she hoped he hadn't left with the key. I said a silent prayer of thanks. However there was no reason to be thankful. Gil opened the door in nothing but his undershorts displaying a marvelous set of biceps, a deep rippled chest and muscular thick legs covered with a golden brown down. What a majestic sight! What a lump in the throat I got when walking into the apartment. I discovered much to my dismay that gorgeous Gil had been sleeping in the spider's web and would probably continue (after he plunged into Sandy for awhile) I felt. It was useless to hope for Gil and Sandy to just fall off to the land of Nod like a couple of tired children and it was useless. All I could concentrate on for the rest of the morning was the grunting and groaning and the sounds of the bed creaking. Gil left around 9 a.m. I was still too stunned to sleep, being persecuted to capacity. As Mr. Right was going out the door he saw I was not asleep and said goodbye. His face seemed to be saying to me it's really you I love mentally it was all you. But then I am not mentally well.

New York, N. Y. 10023, 6/30 1973

Sam Green

14 W 68 St NYC 10023 NY

THOMAS PHARMACY
171 COLUMBUS AVENUE
Bet. 67th & 68th Streets
NEW YORK, N. Y. 10023

		July Balance	26	80		
y. 16		Bottles		59		
		Grace	2	25		
		Born Blonde	2	00		
		Clairol	1	75		
		Zup Wax	1	49		
		Pan Stik	2	35		
		Creme Bevel		75		
		tx		78		
			38	76		

STARDUSK

When you stroll into a party
and the heads neglect to turn
when you're sipping a bacardi
and your face begins to burn—
...that's stardusk

When the dinner's in your honor
but your honor doesn't matter
When you're making a profound statement
and guests begin to chatter—
...that's stardusk

When the glitter on your eyelids
and your sequins start to tarnish
when pancake fails to do the trick
and the next resort is varnish—
...that's stardusk

When the spotlight slowly dims
and you're regretting all your sins
when memories that you hold so dear
are all thats left of your career
...that's stardusk

To whom it may concern

By the time you read this I will be gone.
Unfortunately before my death I had no desire left for
life. Even with all my friends and my career on the
upswing I felt too empty to go on in this unreal
existence. I am just so bored by everything. You might
say bored to death. It may sound ridiculous but is true.
I have arranged my own funeral arrangements with a
guest list and it is paid for. I would like to say goodbye
to Jackie Curtis, I think you're fabulous. Holly, Sam
Green a true friend and noble person, Ron Link I'll never
forget you, Andy Warhol what can I say, Paul Morrissey,
Lennie you know I loved you, Andy you too, Jeremiah
don't take it too badly just remember what a bitch I was,
Geraldine I guess you saw it coming. Richard Turley &
Richard Golub I know I could've been a star but I
decided I didn't want it. Manuel, I'm better off now. Terry
I love you, Susan I am sorry, did you know I couldn't last
I always knew it. I wish I could meet you all again.

Goodbye for Now
Love Always
Candy Darling

Tinkerbell HI!

Life is only what you make it.
Sing along and show that you can take it.
Get in the swing and sing, darn ya, sing.

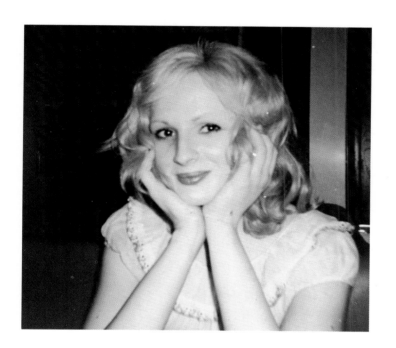

About the Contributors

Mary Harron is a former journalist and documentary film maker. She is the co-writer and director of the feature film I *Shot Andy Warhol*, in which the character of Candy Darling plays a leading role.

Jeremiah Newton is Film Industry Liaison for New York University's Institute of Film and Television. He has written for many publications, lectured widely, and served on film festival juries. He and Candy are both portrayed in the recently released film I *Shot Andy Warhol*, for which he was credited for creating additional scenes and dialog. Of all the major characters in the film, Mr. Newton is the sole survivor. He is currently finishing his script on the life and times of the infamous Max's Kansas City. A major exhibition of the Candy Darling diaries and other material on her life from Mr. Newton's collection is being planned by the Warhol Museum in Pittsburgh.

Francesca Passalacqua works with clothing and fabric, studies Japanese language and culture, and is Associate Editor and co-owner of Hardy Marks Publications. She lived with Candy Darling and Jeremiah Newton from 1971-1972.

Laura Rubin photographed many key people on the scene in New York during the time period covered in this book. She continues to exhibit her work in New York galleries.

Photo Credits

All drawings and text by Candy Darling, ©Jeremiah Newton collection.
Unless otherwise credited, photographers are unknown.

FRONTISPIECE: Andy & Candy. Photo by Sir Cecil Beaton.
 ©Cecil Beaton Estate, J. Newton collection.

The following photographs are by Laura Rubin, 1971, Brighton Beach, Long Island:
 p. 8: Candy and Jeremiah
 p. 21: Candy kneeling
 p. 119: Candy pensive
 p. 128: Candy on the Rocks
 All of the above ©Laura Rubin

p. 16 & 47: Photographs by George Haimsohn.

p. 20: Candy with Tony Milano, 1972. Photo by Ray Blakey.

p. 24: Little Jimmy Slattery, 1953.

p. 44: Watercolor by Jimmy of Kim Novak in the movie *Bell, Book, and Candle*.

p. 58: Candy in *"Some of My Best Friends Are..."* ©American International Pictures 1971.

p. 65: Publicity photo for an off-off Broadway play.

p. 71: Studio photo by Kenn Duncan for *"Some of My Best Friends Are..."*.

p. 81: Candy in the play *Vain Victory*. Photo by Billy Maynard.

p. 91: Mario Montez, Candy, and Dorian Gray in *Vain Victory*. Photo by Billy Maynard.

p. 110: Truman Capote and Candy at Mick Jagger's thirtieth birthday party, 1972.
 Photographer unknown.

p. 125: Photo by Burt Coffman.

Special thanks to Director Thomas Sokolowski and Archivist John W. Smith of the
Andy Warhol Museum, Pittsburgh, for their support of this book and organization of
the exhibit "Candy Darling, Always a Lady." This exhibition will premiere at Feature
Inc. 76 Green Street, New York, from May 16–June 21, 1997. It will appear at the Andy
Warhol Museum from September–November 1997, and travel to other venues
throughout the U.S.

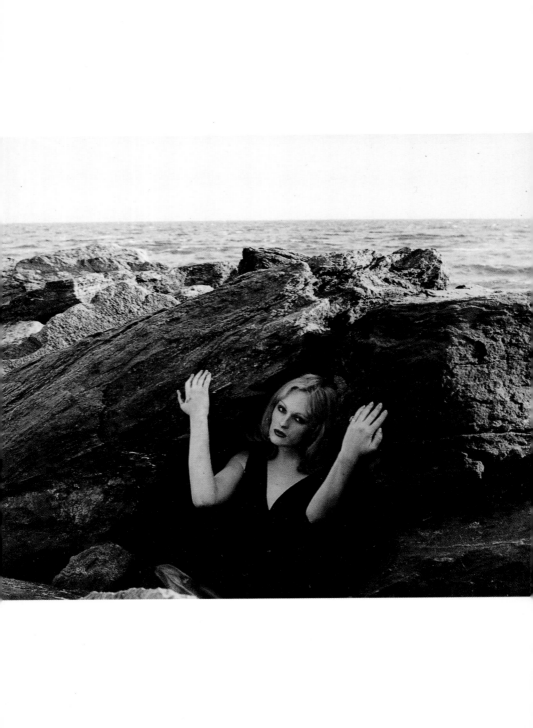